IMAGES
*of America*

# CANA ISLAND
# LIGHTHOUSE

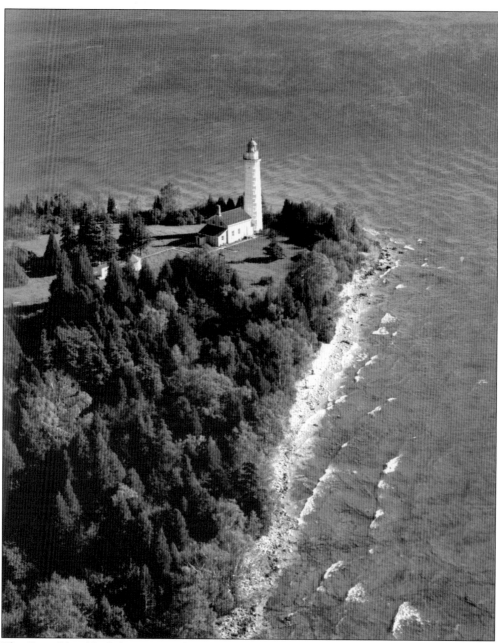

The Cana Island Lighthouse complex rests in a clearing on the eastern end of Cana Island. A stately tall tower, it is one of Door County's most recognizable maritime symbols. (Courtesy Louie and Rosie Janda.)

On the cover: Please see page 58. (Courtesy DCMM&LPS.)

IMAGES
*of America*

# CANA ISLAND
# LIGHTHOUSE

Barb and Ken Wardius

ARCADIA
PUBLISHING

Published by Arcadia Publishing
Charleston SC, Chicago IL, Portsmouth NH, San Francisco CA

Printed in the United States of America

Library of Congress Catalog Card Number: 2006928539

For all general information contact Arcadia Publishing at:
Telephone 843-853-2070
Fax 843-853-0044
E-mail sales@arcadiapublishing.com
For customer service and orders:
Toll-Free 1-888-313-2665

Visit us on the Internet at http://www.arcadiapublishing.com

*To all those who care for the Cana Island Lighthouse,
past, present, and future.*

# CONTENTS

# ACKNOWLEDGMENTS

We were most fortunate that an abundant archive of historic photographs and information existed for Cana Island. People willingly shared their time and family treasures with us. Some photographs were easy to obtain, others were like detective stories. Without a doubt, this project would never have become reality without the help of many folks. First and foremost, June Larson, Brian Kelsey, Trudy Herbst, and the Door County Maritime Museum and Lighthouse Preservation Society (DCMM&LPS) were invaluable. Their archives are second to none. We also are grateful to Jeanne Majeski (Baileys Harbor Public Library); Door County lighthouse historian Steve Karges; Rosie and Louie Janda, former caretakers at Cana Island for photographs and logbook transcribing; Nancy Emery (Door County Library); the United States Coast Guard Aids to Navigation Team in Green Bay; Dawn Holsen, whose father Kenneth Robertson collected many photographs of the early days in Baileys Harbor; Baileys Harbor historian Mary Ann Johnson; Virginia Smiddy; Vivian and Norb Langer; Bill Olson and the Washington Island Archives; Tim Sweet and the Friends of Rock Island; Wayne Sapulski; Virginia Thomas, our "chance" meeting with her at Sherwood Point Lighthouse gave birth to this idea; Doris Rockwell; Coggin Herringa (Crossroads at Big Creek); Leaota Braithwaite; Clyde Brown; Jerry and Judy Brown; Lois Pearson and Margaret Treadway; Orv Langohr; Gary Martin; Randy Zahn; Rick Stram; the Great Lakes Lighthouse Keepers Association Office; Phyllis and Tom Tag (Great Lakes Lighthouse Research); Karen Newbern (the Ridges Sanctuary); James W. Claflin of Kenrick A. Claflin and Son; Julie Miller; the Wisconsin Maritime Museum; and Tim Harrison at *Lighthouse Digest*. Our editor at Arcadia Publishing, Jeff Ruetsche, was extremely patient and helpful in guiding us through this new publication. Lastly, to our family, especially Sarah Lacey Wardius and Sue, Gary, and Nikki Zikmund, who supported us through this endeavor, we offer our sincere thanks and love. We are blessed.

Many of the photographs in this book can be credited to and summarized by the following codes:
AINL: Apostle Islands National Lakeshore
BHPL: Baileys Harbor Public Library
DCMM&LPS: Door County Maritime Museum and Lighthouse Preservation Society
DCL: Door County Library
FORI: Friends of Rock Island
FOWP: Friends of the Wind Point Lighthouse
GLLKA: Great Lakes Lighthouse Keepers Association
NARA: U.S. National Archives and Records Administration
NOAA: National Oceanic and Atmospheric Administration
RS: The Ridges Sanctuary
WIA: Washington Island Archives
WMM: Wisconsin Maritime Museum

# INTRODUCTION

Lighthouses have been guideposts worldwide for centuries. They are synonymous with rich maritime traditions everywhere. If these sentinels could talk, the tales they would tell. Lighthouses are much more than just monuments keeping ships safe, they are a reflection of the human spirit and a mirror to our past.

America is known as a lighthouse leader. Water transit was the most practical, least expensive, and most reliable transportation method in the early history of our country. Increases in shipping naturally necessitated the construction of more lighthouses.

The Great Lakes are a significant part of our heritage and have played a major role in the development and history of the country. The earliest lighthouse on the Great Lakes dates back almost 200 years. The lakes are a 1,000-mile water transportation connection linking ports of the world. Historically the Great Lakes navigation season consumed much of the calendar year, normally open from approximately late March to early December. Great Lakes trade blossomed with wooden schooners in the 1800s hauling wood, grain, ore, coal, and other products. Even with more than 400 lighthouses, over 3,000 ships have gone to their graves on the Great Lakes.

Lake Michigan has its roots in Native American phrases meaning "big water" and "great lake." The sixth largest freshwater lake on earth, Michigan is in excess of 300 miles in length and over 115 miles wide in places. The first Lake Michigan lighthouse was located at the mouth of the Chicago River in 1832. Beginning in the middle of the 19th century, Lake Michigan contained the largest number of Great Lakes lights.

Lighthouses have played a tremendous role in shaping Wisconsin as well. Wisconsin appropriately means "gathering of the waters." Our state was an ideal location for attracting settlers and maritime trade. Waterborne commerce was the lifeblood of Wisconsin.

Wisconsin's "thumb," Door County, is notable for many things. Its uniquely beautiful landscape is bordered by the sometimes dangerous waters of Lake Michigan. The narrow, six-mile-wide strait between the tip of the peninsula and Washington Island connecting the waters of the lake and Green Bay has violent currents at times and dangerous shoals and reefs. Powerful, unexpected shifting winds off Lake Michigan also play a part in the unpredictability of the passage.

The rocky Door Peninsula is approximately 70 miles in length and boasts 10 active lighthouses, 250 miles of shoreline, and five state parks. Lighthouses played a crucial part of its nautical history as Door County became a hub of seagoing business. Despite the presence of lighthouses, however, scores of ships still perished in the waters surrounding "the Door."

The Cana Island Lighthouse is the premier beacon in Door County today. Picture a lighthouse in your mind. Chances are Cana comes close. A familiar light and a distinctive landmark, no other Door County beacon looks like it. Cana Island Light is a classic, a photographer's and artist's delight. Historically the Cana Lighthouse has been an integral part of the peninsula's history and an important aid to navigation for over a century. The lighthouse has witnessed ferocious storms and the subsequent demise of many vessels, both historic and modern, along its

shallow, treacherous reefs. One of Wisconsin's greatest tourist attractions, thousands of people stop at Cana annually. Visiting there today is like taking a journey back in time.

Our initial love of lighthouses began several decades ago at Cana Island. Friends described a wonderful place that immediately grabbed our attention. Since then we have visited Cana dozens of times. Special memories include sunrises with our best friends, the awesomeness of being in the lantern room, and wading the wet causeway in the 1980s with our young daughter Sarah, one of us keeping her dry, the other laden with camera gear.

Cana Island has forever fascinated us. Always wanting to know more of its history and human stories, this book is our attempt at uncovering the lighthouse's many tales. Our research goal is to convey Cana's definitive story. Through photographs both past and present, as well as historical and contemporary information, we hope to express our belief that Cana Island is indeed a very special place. Please feel free to contact us regarding this book:

Barb and Ken Wardius
2240 West Marne Avenue
Glendale, WI 53209
414-228-8947
E-mail: bkw@crestwoodcreek.com
Internet: www.crestwoodcreek.com

We took great pains to insure the accuracy of this book. At times there were conflicting information and dates. Please accept our apologies for any errors or omissions.

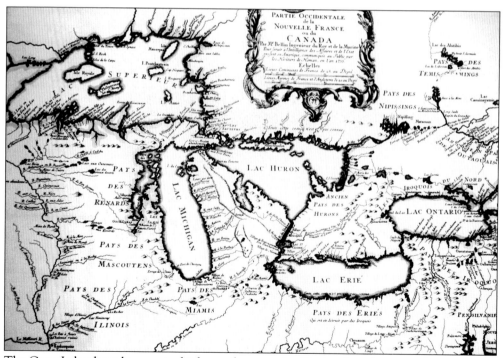

The Great Lakes have been water highways for centuries. Native Americans, explorers, traders, and settlers utilized its resources and transported its goods. This 18th century French map shows these inland waterways, Lake Michigan, what would later become the state of Wisconsin, and the rugged Door County Peninsula and nearby islands. (Courtesy AINL.)

# *One*

# THE BEGINNINGS
## CANA ISLAND'S EARLY YEARS

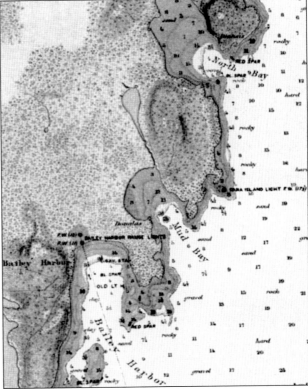

A few miles north of Baileys Harbor, Cana Island was chosen by the Lighthouse Service because it was strategically located between two natural harbors, North Bay and Mud (Moonlight) Bay, where ships could find refuge before encountering the Death's Door passage further north. The island is just over eight and a half acres in size, and its rocky structure juts out into Lake Michigan. Construction of the lighthouse began in 1869. (Courtesy NOAA.)

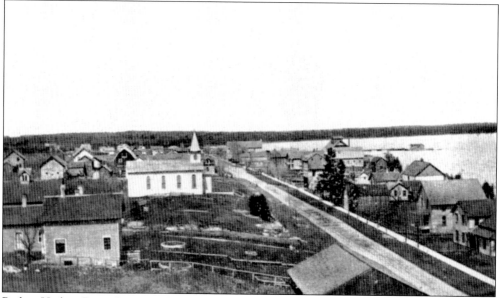

One of the initial acts of our country's first Congress dealt with lighthouses. In 1789, the National Lighthouse Act stated that the treasury department was responsible for lighthouses. The federal government controlled them and dictated rules to states. The U.S. president played an active role in decisions regarding lighthouses. Growing trade in various areas of the country necessitated additional lights. Beginning in 1801, Congress funded lighthouses. (Courtesy DCMM&LPS.)

Baileys Harbor, Door County's oldest village, is nestled in the northwest corner of the bay. Capt. Justice Bailey came upon this natural harbor in 1848. This c. 1917 photograph gives a vantage point of the town looking north. Buildings include many homes, a tavern, other businesses, a church, and some barns. (Courtesy Kenneth W. Robertson.)

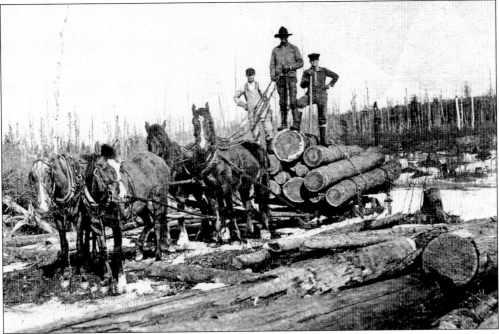

Lumbering was a major activity in the early history of Baileys Harbor. Door County and much of the Midwest similarly relied on wood for day-to-day life and future development. Portions of the surrounding countryside were utilized for the growing demand of forest products nationwide. Teams of lumberjacks and horses helped move this important commodity for many years. (Courtesy BHPL.)

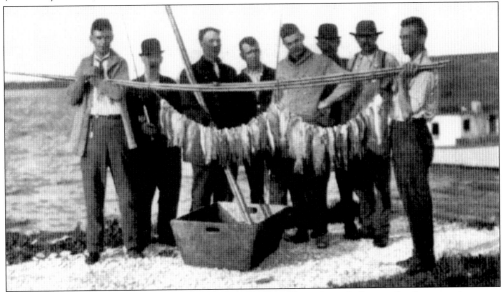

Door County waters teemed with fish. Trout, whitefish, pike, chubs, and other species were significant food sources in the county's earliest days. Many local communities had considerable investments in this enterprise. Commercial fishing operations could also be found around the Door Peninsula. These local Baileys Harbor fishermen display a bountiful catch. (Courtesy Kenneth W. Robertson.)

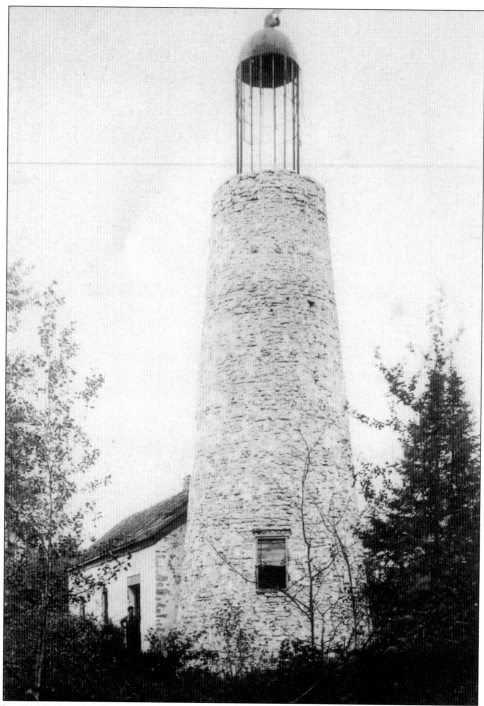

The Old Baileys Harbor Lighthouse, built in 1851, was the first lighthouse on the main Door Peninsula. Referred to as the "bird cage" lighthouse, because of the style of the lantern room it possessed, the Old Baileys Lighthouse had a relatively short life. A safe entrance to Baileys Harbor, around many tricky shoals, was not provided by this light because of its poorly selected position. (Courtesy Kenneth W. Robertson.)

Instead of repairing the old light, the government replaced it with the Baileys Harbor Range Lights and the Cana Island Lighthouse, both built in 1869. The Range Lights provided a much safer entrance into Baileys Harbor. In this undated photograph, the John Anclam family enjoys a day on Lighthouse Island, as it was called then. In December 1869, keeper William Darling extinguished the Old Baileys light for good. (Courtesy Kenneth W. Robertson.)

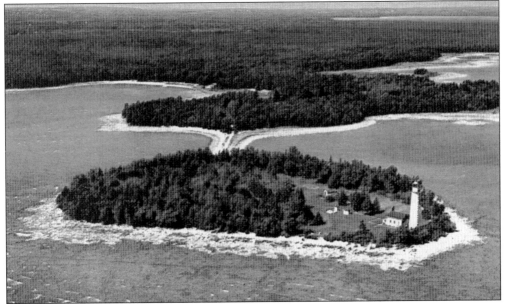

Cana Island is detached from the mainland when Lake Michigan's level is high enough and can be a peninsula during lower water levels, when its 300-foot-long limestone causeway is exposed. Visitors can either be completely dry or may face knee-deep wading. The surrounding waters are quite shallow and can be treacherous with rugged shoals and reefs. (Courtesy Louie and Rosie Janda.)

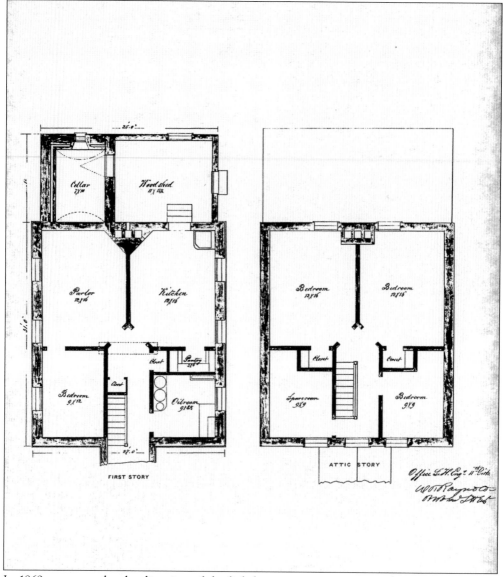

First story labels: Cellar 7x10, Wood shed 11x14½, Parlor 12x16, Kitchen 12x16, Bedroom 9x12, Closet, Cont, Pantry, Oil room 9x8½

FIRST STORY

Attic story labels: Bedroom 12x16, Bedroom 12x16, Closet, Closet, Spare room 9x9, Bedroom 9x9

ATTIC STORY

Office L.H. Eng'r. 11th Dist.
W.O. Raynolds

In 1869, a crew under the direction of the lighthouse engineers excavated out an area for the basement of the home. Cana was suitable for two households. The keeper and his family lived in the five rooms on the first floor, and the assistant, if not a member of the keeper's family, lived on the second floor in four rooms. Rank definitely had its privileges! (Courtesy DCMM&LPS.)

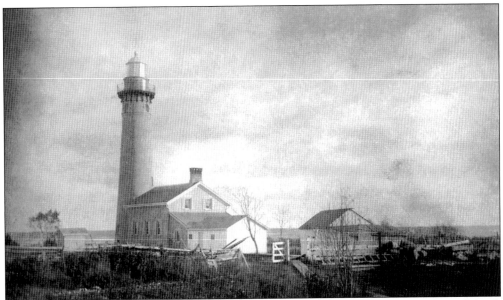

This 1883 photograph shows the earliest look at Cana Island with its original 86-foot-tall brick tower, buildings, yard, and walkways. Designated a coastal light, the island was lower than it appears today, with little land much above lake level. Severe storms during this era wreaked havoc all over the compound. In 1890, thousands of yards of fill would be added to Cana by men and teams of horses. (NARA photograph Courtesy Wayne Sapulski.)

The light tower at Cana Island was originally constructed of yellowish Milwaukee cream city brick, the same as the keeper's house that is still seen today. The brick was a common building material used throughout the Midwest in the 1800s. The tower walls are massive, nearly four feet thick at the base. The light tower was the tallest brick structure in Door County in 1869. (Authors' collection.)

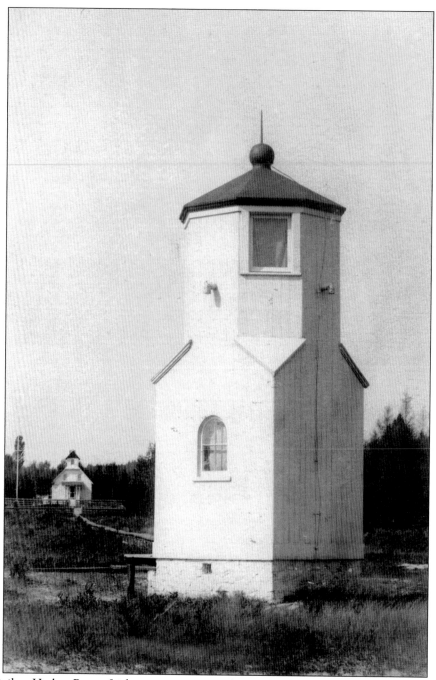

The Baileys Harbor Range Lights were constructed in 1869, along with the Cana Island Light, to replace the Old Baileys Harbor light. This 1907 photograph shows the Baileys Harbor Front Range Light in the foreground. Situated closer to Lake Michigan, it is 950 feet from the Rear Range Light in the background. The Front Light was a steady red beam. When entering the harbor, captains kept the more elevated white light of the Rear Light directly over the red color shown by the Front Light. This keeps the ships "on range" and leads mariners in a straight line safely into the harbor. (Courtesy Kenneth W. Robertson.)

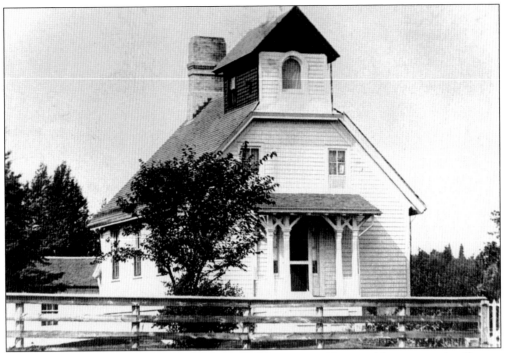

The Baileys Harbor Rear Range Light, pictured here, resembles an old country schoolhouse. The keeper lived here with his family. This beacon was a fifth order Fresnel lens, with a steady white light, and was located in the cupola atop the dwelling. After automation, this building was used as a residence for a Lutheran minister. (Courtesy RS.)

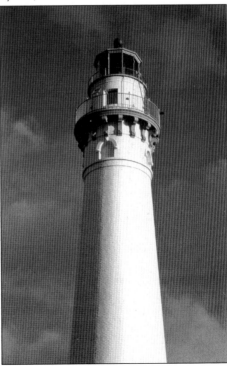

Cana Island's light tower style is similar to several other notable Great Lakes lights. Wind Point Lighthouse in Racine, Wisconsin, pictured here, as well as Outer Island on Lake Superior, Grosse Point in Illinois, and Presque Isle on Lake Huron, among several others are all tall, tapered, brick towers with flared ornamentation near the towers' top. (Authors' collection.)

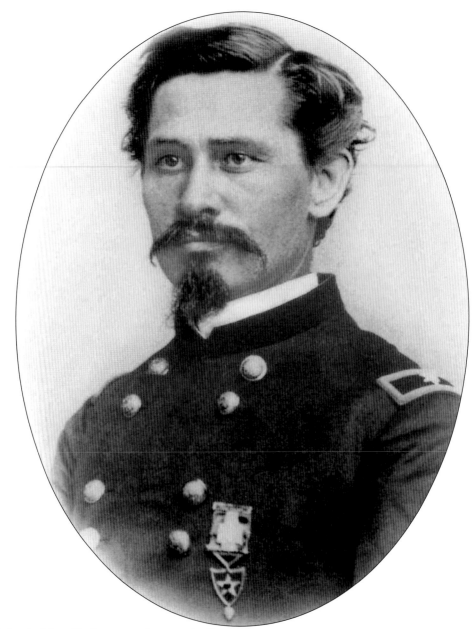

Orlando Metcalfe Poe was a decorated officer in the Union Army during the Civil War. Later he was one of the top engineers in the Lighthouse Service. Placed in charge of lighthouse building projects, he later was promoted to chief engineer of the upper Great Lakes District. Poe is credited with designing many lighthouse towers, defined as the "Poe style" today. The Cana Island tower bears a striking resemblance to this type of tower. However, it is unknown if Poe was directly involved in Cana's tower design. His talents made a lasting mark on many U.S. lighthouses. (Courtesy U.S. Military History Institute.)

*Two*

# STATION BASICS
## THE LIGHT, FRESNEL LENS,
## AND TECHNOLOGY CHANGES

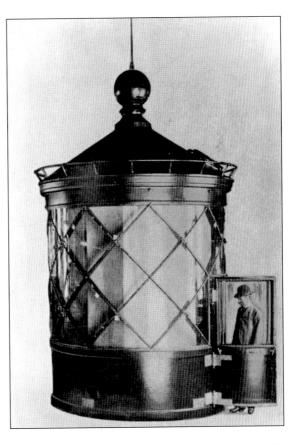

This 1898 photograph comes from the
official annual report of the Lighthouse
Board to the secretary of the treasury.
It shows a man entering a third order
lantern room, Cana's designation.
Nearly 15 feet tall from the base to its
tip, the lantern room's most important
component is the Fresnel lens. (Courtesy
Steven Karges.)

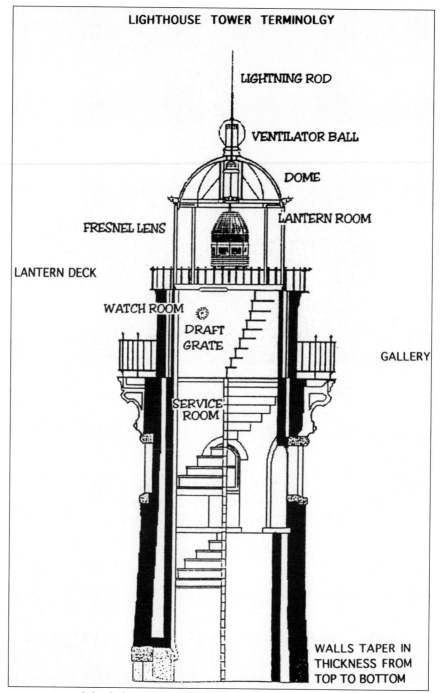

LIGHTHOUSE TOWER TERMINOLGY

LIGHTNING ROD

VENTILATOR BALL

DOME

FRESNEL LENS

LANTERN ROOM

LANTERN DECK

WATCH ROOM

DRAFT GRATE

GALLERY

SERVICE ROOM

WALLS TAPER IN THICKNESS FROM TOP TO BOTTOM

The upper portion of the light tower is the heart of the lighthouse. This diagram highlights many of Cana's major components. A lightning rod tops off the lantern, the ventilator ball exhausted gases from the burning of liquid fuels, the main lantern room houses the lens, and service and watch rooms were used for equipment and storage. Cana's focal plane, the vertical distance from the focal point of the lens to the water surface, is roughly 89 feet above the average level of Lake Michigan. (Courtesy GLLKA.)

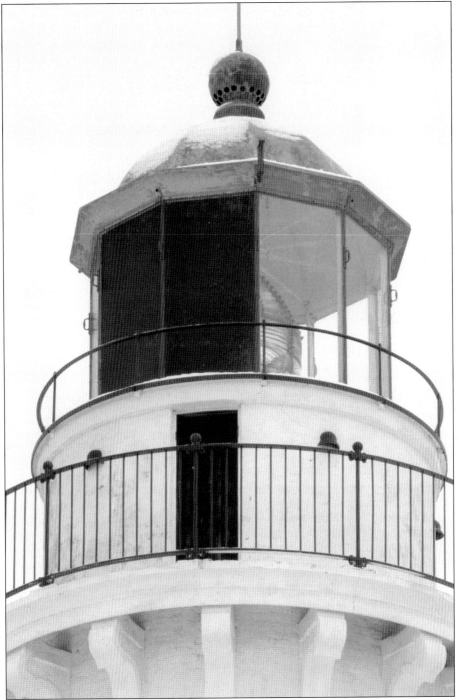

Cana's top has many associated structures, including railings around both the watch and lantern rooms. A copper dome supports a ventilator ball (its holes are clearly visible) and lightning rod. Clear glass panes, 5/16 inches thick, face Lake Michigan. The back side of the lantern faces land and is darkened to direct all of the light beams out over the water. A doorway gave the keepers access to the outside of the lantern room. (Authors' collection.)

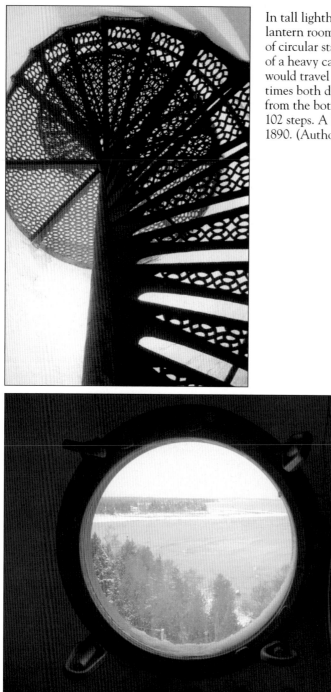

In tall lighthouse towers, access to the lantern room was accomplished by a column of circular stairs. Cana's steps are constructed of a heavy cast-iron material. The keepers would travel up and down the stairway many times both day and night. They were taken from the bottom to the base of the lamp by 102 steps. A handrail was not added until 1890. (Authors' Collection.)

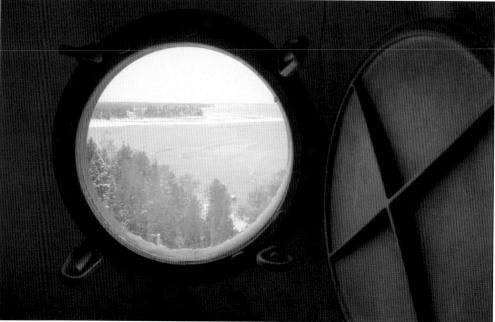

Stopping along the way up or down the circular stairway, the keepers could peer out the six portholes and gaze along the length of the Cana coastline, looking for vessels in danger, ships passing by, or changes in weather and wave conditions. These portholes were even equipped with small screens for ventilation during the warmer summer months. (Authors' collection.)

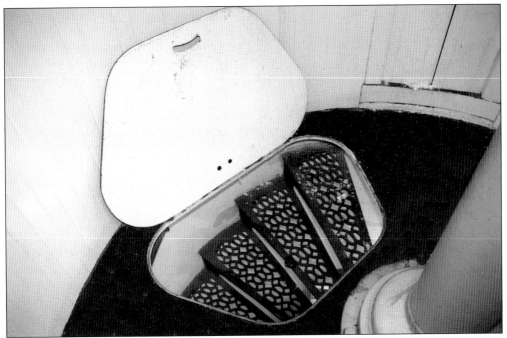

Lofty light towers usually feature several hatches along the route to the tower's top. Cana has a single one, at the base of the lantern room. One hatch function is to separate off the lens area from the rest of the tower. Hatches and draft grates could be opened or closed to regulate the amount of air going to the lantern room to improve the lamps' burning. (Authors' collection.)

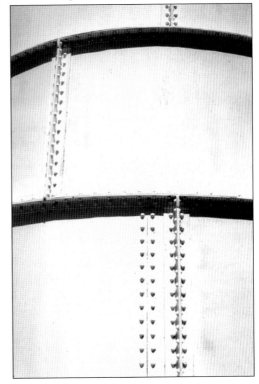

Most people do not know that Cana Island's original tower was constructed of brick. Almost all historical photographs of the tower show a light-colored metal tower. The close-up view pictured here shows the fine workmanship of the seams and rivets. Over a century later, the Cana Island tower is still shielded well by this iron material. (Authors' collection.)

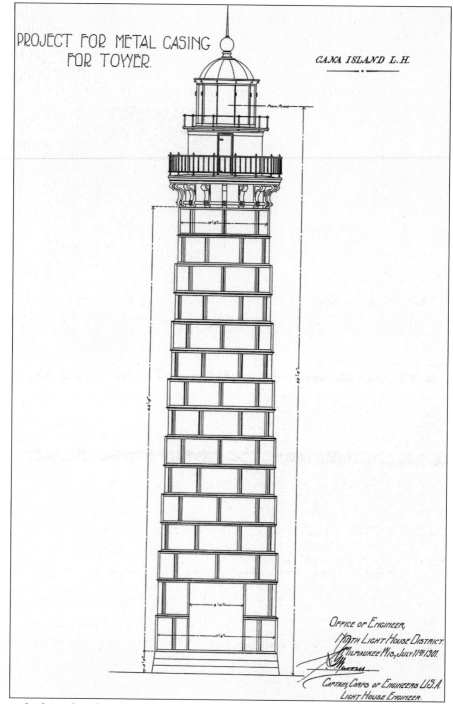

PROJECT FOR METAL CASING
FOR TOWER.

CANA ISLAND L.H.

OFFICE OF ENGINEER,
NORTH LIGHT HOUSE DISTRICT.
MILWAUKEE WIS., JULY 11TH 1901.

CAPTAIN, CORPS OF ENGINEERS U.S.A.
LIGHT HOUSE ENGINEER.

After only three decades of use, the government noted the brickwork at Cana was weathering rapidly. In 1901, plans were drawn up to renovate the tower without tearing it down. A year later the tower was encased in 15 tiers of riveted iron sheeting, and concrete was poured between the brick and new plating. Pictured here is the lighthouse engineers' drawing of the project. (Courtesy DCMM&LPS.)

The outhouse, most commonly called a privy, was built in October 1906. Constructed of brick, it had a shingled roof and a concrete pit for easy cleaning! It is not known with certainty how families at Cana took care of their wastes prior to this. It probably was no more elaborate than a pit dug into the ground in a shelter. Sanitation issues still are a concern today at Cana. (Authors' collection.)

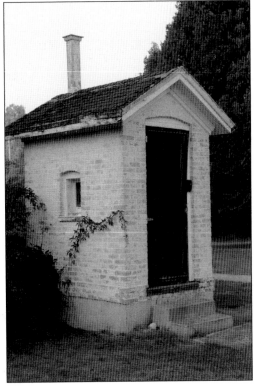

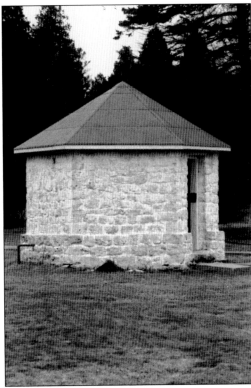

The oil house or fuel shed was constructed of stone in 1890. Since mineral oil or kerosene was highly flammable and considered dangerous to store in the keepers quarters or in the tower, a detached, well-built structure was a necessary improvement. The oil house at Cana Island is distinctive with its hexagonal shape. Today the oil house contains information about the building, fishing, and shipwrecks. (Courtesy Steven Karges.)

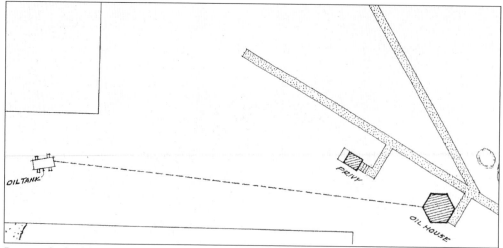

Prior to the building of the oil house, kerosene was brought in bulk to Cana Island via lighthouse tenders. Barrels were transported from the western side of the island by wheelbarrow. Five-gallon containers weighed nearly 50 pounds, larger containers considerably more. Originally oil tanks were set in place by the boathouse. This diagram shows the location of a later (1925) tank directly connected to the oil house. (Courtesy DCMM&LPS.)

In 1925, after several decades of hauling barrels of kerosene from the far side of Cana Island, the keepers moved one of the boathouse area oil tanks. They constructed concrete supports nearer the oil house and employed an underground pipeline to feed mineral oil directly to the oil house. After Cana was automated, all the oil tanks were removed. Cement struts are all that remain. (Authors' collection.)

26

Two September 1906 logbook entries read as follows: "Supt. Comfort and crew of men arrived at 5.0 p.m. Working party began making cement walks." By October 2, the cement sidewalks had been completed. This was a welcome improvement for the keepers. Prior to this, the walkways were wooden and often swept away in times of high water. A permanent sidewalk record is stamped with this lone date. (Authors' collection.)

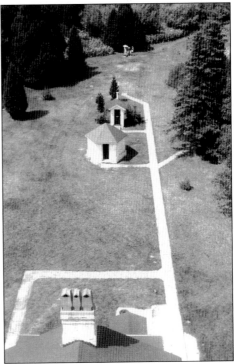

Viewed from the assistant keeper's living quarters on the second floor at Cana Island, the cement sidewalks led to various outbuildings. The oil house, privy, icehouse, workshop, garage, and barn were all easily accessible. A large barn was located at the west end of the existing sidewalk, which would explain the turn in the walkway. (Courtesy Steven Karges.)

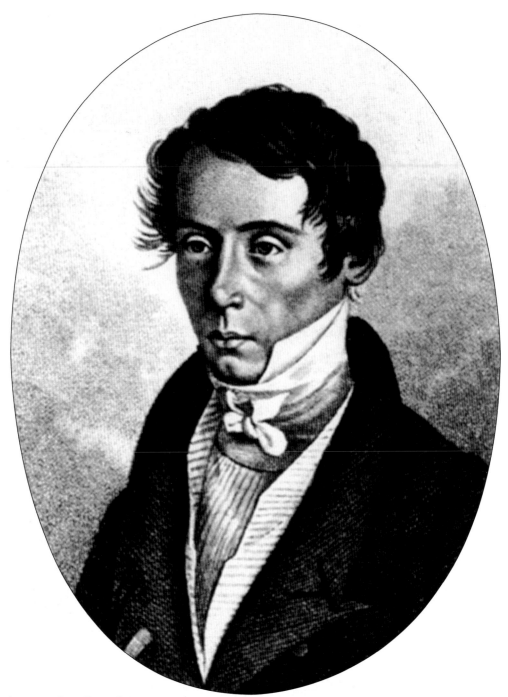

Augustin Jean Fresnel, (pronounced fruh-nell') was a French physicist born in 1788. Credited with designing a lens that revolutionized lighthouses worldwide, Fresnel developed a compound lens in 1822 that later would bear his name. The Fresnel design brought a marked improvement in the effectiveness of lighthouses. Light beams were considerably more intense and could be seen many additional miles away by mariners. Fresnel lenses also significantly decreased fuel costs. (Courtesy FOWP.)

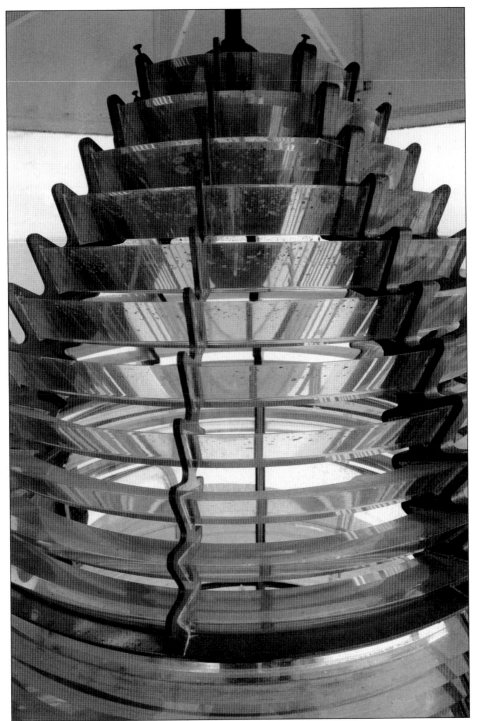

There are six sizes, or orders, of Fresnel lenses. First order is the largest and sixth order the smallest. The range and concentration of the light produced varied similarly. Cana's lens is a third order, stands over five feet tall, and weighs almost a ton. Third order lenses are used primarily in coastal lights. Cana's was first officially lit on January 28, 1870. (Authors' collection.)

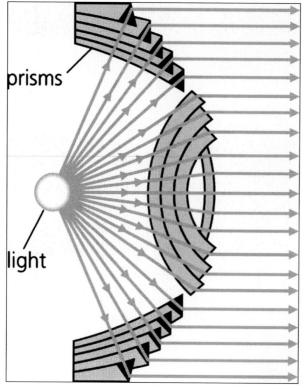

prisms

light

Fresnel lenses are built with multiple tiers of prisms that bend and reflect all the different light rays. The final results are parallel light rays, focused into an efficient, intense beam. The Fresnel lens principle is still used in lens design today. Some modern uses include car headlights, traffic signals, flashing emergency vehicles, and movie projector lights. (Authors' collection.)

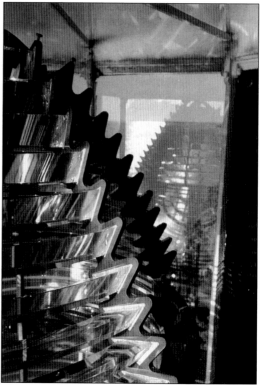

A shiny brass framework holds the crystalline lens together. The shape of these hand-polished cut-glass lenses has been likened to a potbellied stove, a beehive, or a barrel. Cana Island still sports its original Fresnel lens, making it Wisconsin's oldest original Fresnel lens still in operation today. Its steady white light is visible for approximately 18 miles out over the lake. Keeping the lens spotless was an everyday chore. (Courtesy DCMM&LPS.)

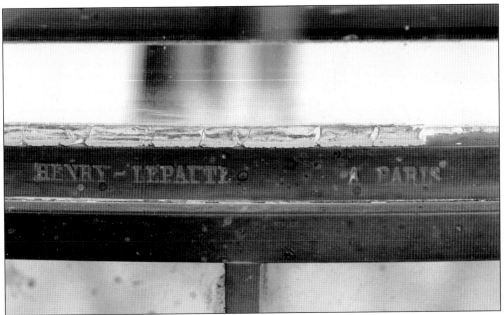

Several companies built Fresnel lenses during the 1800s. They included Barbier and Fenestre; Henri LePaute; and Sautter, Lemonier and Cie. The lenses would be built in Paris, ferried unassembled across the ocean, and then erected in the lantern room of the lighthouse. The workmanship of these lenses is remarkable even by today's standards. Cana's lens is an engineering marvel over 100 years old. It is stamped "Henry-LePaute A Paris." (Authors' collection.)

Regulations stated the light had to be ignited 30 minutes before sunset, kept burning all night, and extinguished 30 minutes after dawn every day. Fuel consumption was closely monitored. There was little room for excuses when it came to having a dependable working light. Many light stations were supplied with a clock such as the one pictured here around 1915. (Courtesy James Claflin.)

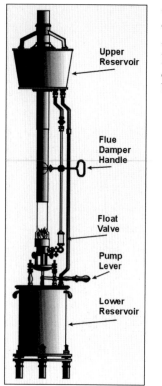

Upper Reservoir

Flue Damper Handle

Float Valve

Pump Lever

Lower Reservoir

Various lamps were employed at Cana to hold and burn fuel. The Joseph Funck lamp was the first installed. Several wicks were part of this apparatus, and it originally used lard oil for fuel. Less volatile than later oils, lard oil had one big drawback. In colder weather, it would become quite thick and would need to be warmed and liquefied prior to use. (Courtesy Tom Tag.)

The keepers were in charge of insuring the light remained lit by keeping the fuel replenished and repeatedly, every few hours or so, pruning the wicks precisely to insure a clean burn. This chore gave rise to them being known as "wickies." Pictured here is a U.S. Lighthouse Service lamp-filling can. (Courtesy James Claflin.)

Pressurized oil-burning lamps were another type of light source. They were an improvement over some earlier oil-burning models that more simply employed gravity, capillary action, and oil in reservoirs. Under a regulated pressure, oil would flow more consistently to the wicks and the resulting light produced was considerably more even and dependable. (Courtesy GLLKA.)

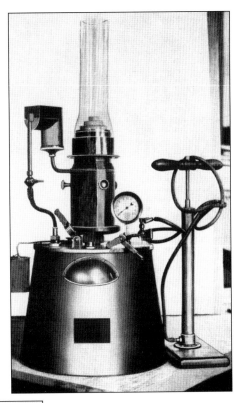

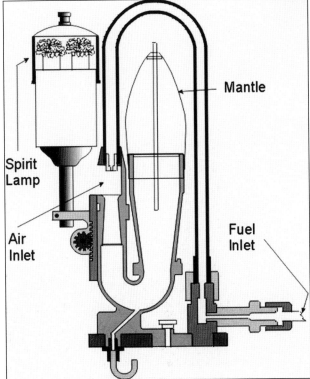

Mantle

Spirit Lamp

Air Inlet

Fuel Inlet

The incandescent oil vapor (IOV) burner became the new lamp at Cana Island in 1910. Resembling our modern day Coleman lantern, a mantle served as the place where pressurized oil and air combusted to produce a more brilliant light. A very reliable apparatus, the IOV was in use in Cana's lantern room for several decades. Beginning in 1924, acetylene gas replaced the IOV in winter. (Courtesy Tom Tag.)

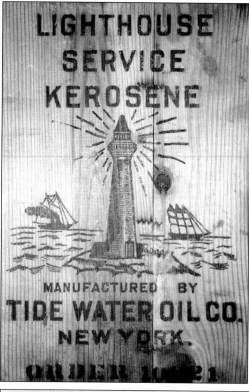

The most common oils employed in lighthouses included whale, lard, and kerosene. Known as mineral oil, kerosene was first used at Cana Island in 1882. Relatively cheap, it was highly flammable and burned more brilliantly than previous oils. The kerosene used in lighthouses was a special blend. Not the normal fuel that would usually burn a smoky, yellow flame, this special kerosene emitted a clear, white light. (Authors' collection.)

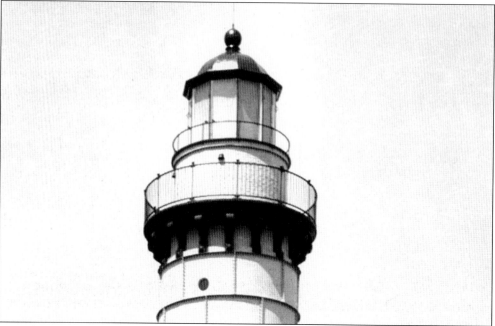

Once kerosene became the primary fuel in most lighthouses, shades or curtains were placed in lantern rooms. One of the purposes of the shade was to minimize the danger of sunlight igniting kerosene fuel or vapors atop the tower. The coverings also helped protect the precious Fresnel lens. Cana's lantern room curtains are clearly drawn in this photograph. (Courtesy DCMM&LPS.)

Prior to the time that electricity finally came to Cana Island, keepers and their families relied on oil lamps for day-to-day lighting. Mineral oil was the main fuel used. Lanterns such as the one pictured here would have lit the various rooms after dark and would have been held firmly in the keeper's hands going up and down the tower at night. (Authors' collection and FORI.)

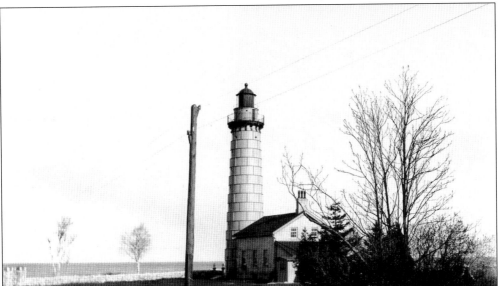

Electricity did not come to the Cana Island light tower until 1934. The house was not electrified, only the lantern room. Some descendants of keepers specifically recall the lack of electricity in the house. Electrification at Cana, however, did change lighthouse tending there forever. Electricity greatly reduced lantern room maintenance. Automation of the light station was down the road a bit, but was now a certainty. (Courtesy DCMM&LPS.)

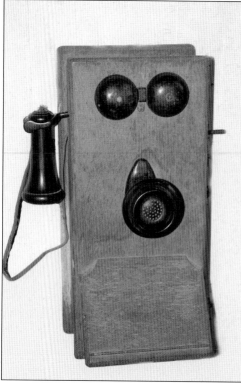

Telephone communications began at Cana Island in the early 1900s. Previously, telegrams were received. Early telephone use was sporadic, as there are many logbook entries that detail telephone service outages due to fallen trees downing the telephone lines. The telephone was to be used strictly for government business. Originally only one telephone was available, but an extension telephone saw service in the kitchen beginning in June 1926. (Authors' collection.)

The light at Cana Island was automated in 1944. Technology has progressed so far that currently it is illuminated by one of a series of small 250-watt projection bulbs. Four rotating, automatically changeable bulbs prevent the light from ever going dark for more than an instant. When a bulb burns out, the next one immediately takes its place, insuring the light continues its important work. (Authors' collection.)

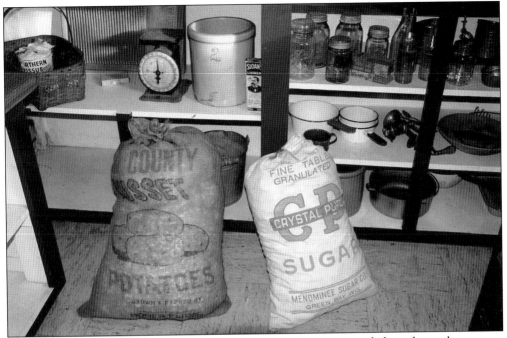

Food was obtained in various ways. The Lighthouse Service provided staples such as meat, flour, potatoes, rice, beans, sugar, and coffee. A large vegetable garden and fruit trees on the island were harvested. Some Cana families had cows and chickens. Hunting and fishing were an additional supplement. Routine trips to the general store in Baileys Harbor would be taken. (Authors' collection.)

Cooking at Cana Island was not as easy a task as cooking is today. Originally a heavy-duty wood-burning stove was utilized. Large volumes of water were boiled on stoves for consumption. Later in the 1930s, the logbook mentions the delivery of an oil-burning cook stove. Both floors of the main lighthouse building had a stove at one time. (Authors' collection and FORI.)

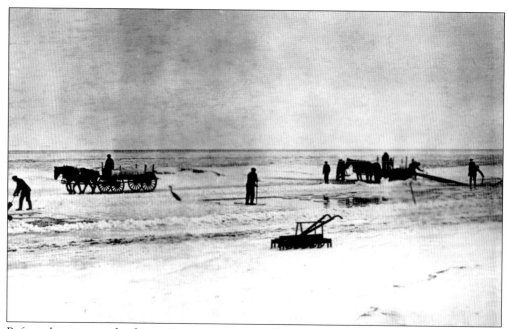

Before electricity and refrigeration were common, food spoilage was an issue. Pictured here is winter ice cutting in Baileys Harbor. In the 1930s, ice at Cana was obtained from an icehouse near Gordon Lodge in North Bay, four miles away. Ice blocks would preserve food in an enamel icebox. Cana Island also had a means of smoking some foodstuffs, as smoking ham is mentioned in a 1921 logbook. (Courtesy BHPL.)

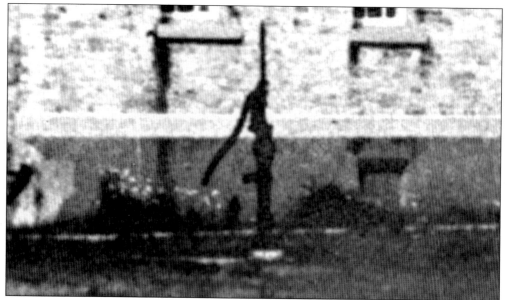

Surrounded by water, Cana actually had its problems when it came to clean, usable water. Much of the water utilized came directly from Lake Michigan. Well drilling began as early as 1896 and continued for several decades with mixed results. At times, a cistern collected rainwater. The old hand pump in the yard is shown here. Today there is still no reliable source of drinking water at Cana Island. (Courtesy Steven Karges.)

Water was a precious commodity at Cana Island. Buckets would have routinely been dipped in the lake. A well sometimes gave good quality water. Jugs were filled from mainland sources. Precipitation from the roof was directed via gutters and downspouts to a cistern in the basement. The hand pump shown here is in a first-floor pantry, and another pump from the cistern was on the second floor. (Authors' collection.)

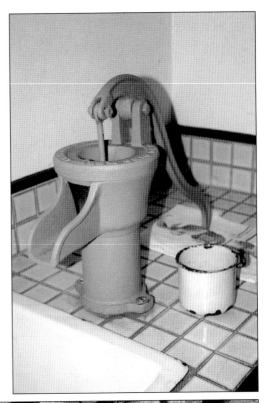

Wood was another important valuable resource at Cana Island. Timber cutting, log splitting, and other associated chores can be found in logbook entries year round for many decades. Wood was utilized as a heating source in fireplaces. Wood-burning stoves cooked meals. The original plans for Cana Island included a woodshed attached to the rear of the main dwelling. An outdoor woodshed was usually filled. (Authors' collection.)

Over the years, Cana Island received hundreds of tons of coal. In its earliest days, lighthouse supply ships, tenders, transported bulk coal to Cana. Deliveries in the late 1890s averaged one and a half tons. Later it was common for 5 to 10 tons of the fuel to be brought. Keepers and assistants moved the coal via wheelbarrow from the opposite side of the island near the causeway to the lighthouse. (Authors' collection.)

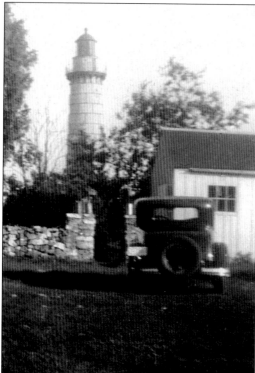

The first mention of an automobile in the logbooks at Cana Island dates to 1916. Keeper Oscar Knudsen was the first to own a car in 1920. His wife, Maud, also drove. All subsequent personnel at Cana had a vehicle. This afforded them considerably more mobility. They would regularly travel to Baileys Harbor and other destinations throughout Door County. (Courtesy Clyde Brown.)

## *Three*

# THE KEEPERS
## DECADES OF DEDICATION AND CARE

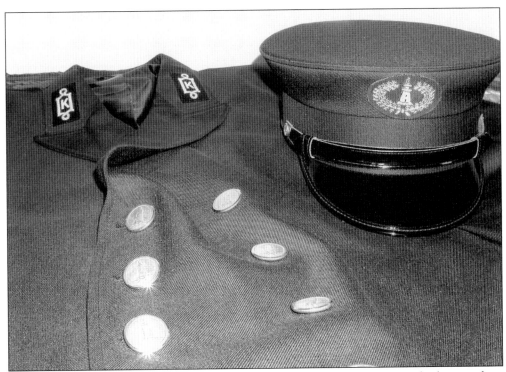

The Lighthouse Board instituted a uniform for male light keepers, consisting of a dress uniform as well as fatigues for working. The dress uniform incorporated a coat, trousers, vest, and cap all made of dark blue flannel or jersey. Two rows of five yellow metal buttons (with a lighthouse) dressed up the front of the double-breasted coat. The cloth cap had a lighthouse badge fastened immediately above the bill. (Authors' collection.)

## CANA ISLAND LIGHTHOUSE KEEPERS AND ASSISTANTS

| NAME | POSITION | DATE |
|---|---|---|
| WILLIAM JACKSON | KEEPER | 1869 - 1872 |
| CAROLINE JACKSON | ASSISTANT | 1869 - 1872 |
| JULIUS WARREN | KEEPER | 1872 - 1875 |
| SARAH WARREN | ASSISTANT | 1873 - 1875 |
| WILLIAM SANDERSON | KEEPER | 1875 - 1891 |
| SARAH SANDERSON | ASSISTANT | 1875 - 1882 |
| CLIFFORD SANDERSON | ASSISTANT | 1884 - 1889 |
| PATRICK CHAMBERS | ASSISTANT | 1889 - 1890 |
| JOSEPH KILGORE | ASSISTANT | 1890 |
| JESSE BROWN | KEEPER | 1891 - 1913 |
| JAMES McINTOSH | ASSISTANT | 1891 - 1893 |
| LAWRENCE BROWN | ASSISTANT | 1893 - 1899 |
| HENRY BEVRY | ASSISTANT | 1899 - 1902 |
| EMIL MUELLER | ASSISTANT | 1902 - 1905 |
| REINHART PFIEL | ASSISTANT | 1905 - 1909 |
| JOSEPH STODOLA | ASSISTANT | 1909 - 1911 |
| MORITZ WEISS | ASSISTANT | 1911 - 1919 |
| CONRAD STRAM | KEEPER | 1913 - 1918 |
| OSCAR KNUDSEN | KEEPER | 1918 - 1924 |
| LOUIS PICOR | ASSISTANT | 1919 - 1920 |
| A. SULLIVAN | ASSISTANT | 1920 |
| JOHN HAHN | ASSISTANT | 1920 - 1921 |
| CHARLES LINSMEIER | ASSISTANT | 1922 |
| HENRY GATTIE | ASSISTANT | 1922 |
| SAMUEL HANSON | ASSISTANT | 1923 |
| THEODORE GROSSKOPF | ASSISTANT | 1923 - 1932 |
| CLIFFORD SANDERSON | KEEPER | 1924 - 1933 |
| ROSS WRIGHT | ASSISTANT/KEEPER | 1932 - 1941 |
| MICHAEL DREZDZON | ASSISTANT/KEEPER | 1933 – 1942? |
| DONALD LANGOHR | U.S. COAST GUARD | 1939 – 1942 |

Keepers are the soul of a lighthouse. Only a very select group of people were ever keepers or assistant keepers and caretakers at Cana Island. Beginning in late 1869 and ending over a century later in 1995, Cana has been tended by some very dedicated individuals. Nine keepers, about two dozen assistants, a caretaker family, and the Coast Guard made up the list of Cana custodians. (Courtesy Phyllis Tag, Rosie Janda, and Steven Karges.)

## Record of Lights—Keepers' Names—

| Name of Light Station. | Name of Keeper and Assistants. | Rate. | Annual Salary. | Date of Appointment. |
| --- | --- | --- | --- | --- |
| Cana Island | William Jackson | Keeper | 600 | Nov'r 3 1869 |
| | Caroline Jackson | Assistant | 400 | " " " |

William Jackson, a farmer, was Cana's inaugural keeper. His 1869 annual salary was $600, and his assistant, wife Caroline, earned $400. In addition to their pay, the Jacksons had a new brick home to live in and were supplied with meat, coffee, sugar, rice, and other provisions. Families normally planted a vegetable garden, and they likely fished and hunted. They journeyed to the mainland by small sailboat for other foodstuffs. (Courtesy DCL.)

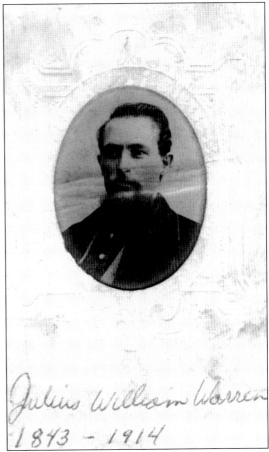

Julius William Warren, an army veteran who served under Gen. William Tecumseh Sherman, was keeper from 1872 until 1875. Many of the early light keepers were veterans of the Civil War, and some received their positions due to political considerations. Later the Lighthouse Board brought these positions under an entitlement system. Lighthouse keepers were included in the Civil Service System in 1896. (Courtesy Leaota Braithwaite.)

Julius William Warren
1843 – 1914

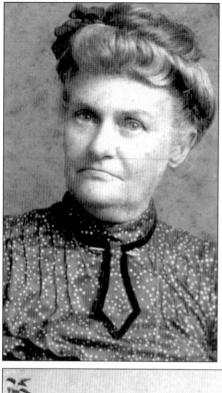

Sarah C. Boulin of Peshtigo, Wisconsin, married Julius Warren on April 21, 1866. Sarah Warren was assistant keeper at Cana Island with her husband. This undated photograph is from the period that the Warren family lived on their farm. They built their home in Clay Banks, south of Sturgeon Bay along Lake Michigan. The Warren's lighthouse wages may have been used to help them financially on the farm. (Courtesy Leaota Braithwaite.)

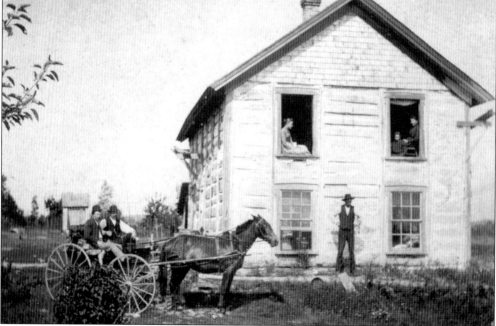

This 1891 photograph shows the Warren's house in Clay Banks. During this time period, most Door County homes were considerably more modest than this one. Other than the three years that Julius Warren served at Cana Island, the Warrens made their home here on the farm. The name Clay Banks came from sailors who would see the high clay banks along the shore many miles out on Lake Michigan. (Courtesy Leaota Braithwaite.)

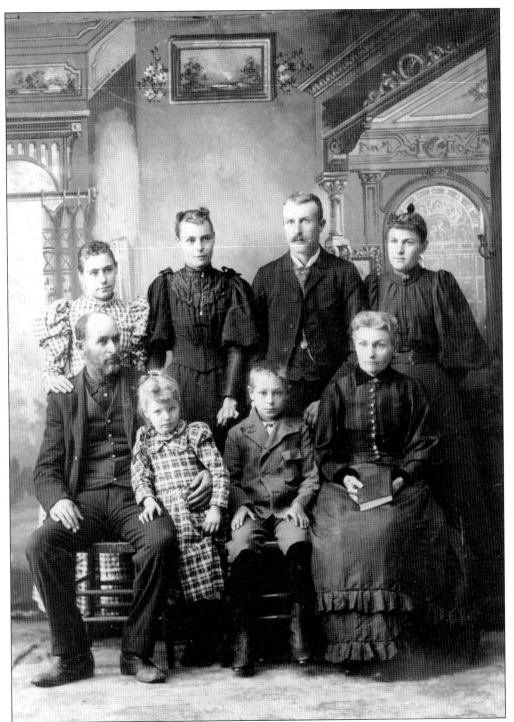

Several years after Julius Warren left the U.S. Lighthouse Service, he and his growing family posed for this more formal 1895 portrait. Pictured from left to right are (first row) Julius Warren, Sarah Rosina (called Nina), Harry, and Sarah (wife of Julius, holding book); (second row) Minnie, Eliza, Bert, and Jesse. (Courtesy Leaota Braithwaite.)

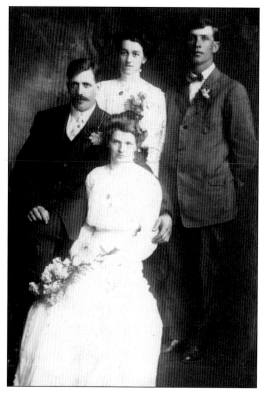

The Warren's youngest daughter, Sarah Rosina "Nina" Warren, married Charles William Helmholz on April 18, 1910, at the Warren house in Clay Banks. Several Cana Island families celebrated weddings during their lighthouse years. The Jesse Brown family recorded in its logbook their attendance at their son Albert's wedding in Sturgeon Bay in 1901. Several members of the Janda family, caretakers from 1975 to 1994, also celebrated their weddings in the 1990s. (Courtesy Leaota Braithwaite.)

During the winter of 1877, lighthouse keeper William Sanderson (1875–1891) spotted a small boat in an ice floe off Cana Island. Two human figures, a father and son, sat hunched over in the vessel. Frozen to death, they drifted past the lighthouse and were never seen again. On October 16, 1880, Sanderson also witnessed the Alpena Gale. His logbook entry called it "the most destructive ever known on the lake." (Courtesy DCMM&LPS and Julie Miller.)

Cana keeper William Sanderson married Sarah Rice in 1867. She was the daughter of distinguished Door County judge Daniel Rice. Sarah's sister was married to Joseph Harris Jr., whose father, Joseph Harris Sr., was a political ally of Congressman Philetus Sawyer, pictured here. Sawyer was a prominent Wisconsin businessman and politician. Perhaps Sanderson had the inside track at Cana because he was a war veteran and had connections to Sawyer. (Courtesy Timm Severud.)

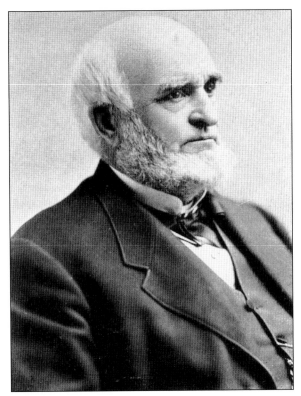

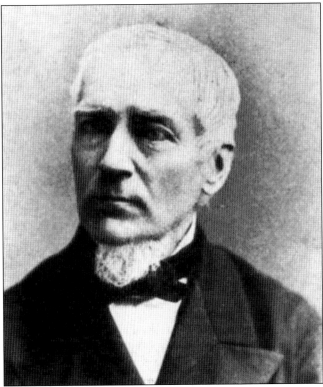

The Sanderson family would on occasion receive visits from the Harris family at Cana Island, and a friendship developed. Joseph Harris Jr. supplied various boats to the Lighthouse Service. His father, Joseph Harris Sr., pictured here, was a driving force for the building of the Sturgeon Bay Ship Canal and politically connected. Joseph Harris Sr. became the editor of the *Door County Advocate*, the local newspaper that still is published today. (Courtesy BHPL.)

Jesse Thomas Brown (1891–1913) was the first keeper to remain at the lighthouse during the winter months when the navigation season ended. Even before the season closed for the winter, his logbook entry from November 17, 1892, states, "Wind North blowing a gale. 6:30 p.m. Wind blowing a perfict (sic) gale, can scarsely (sic) walk outside and steady rain." Brown's service at Cana is the longest, almost 22 years. (Courtesy Jerry Brown.)

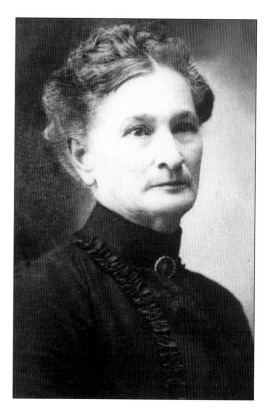

Hannah Foster Brown married Jesse Brown in August 1868. They had six children, all boys: Roland, Volney Clair, Lawrence (who became keeper at Pottawatomie light station on Rock Island in 1899), Albert (served in the Life-Saving Service at Sturgeon Bay), Marion Lloyd, and Maxwell Ray. Hannah would later retire in Florida near her son Roland. (Courtesy DCMM and LPS.)

Jesse Brown served in the Civil War and achieved the rank of corporal. His son Lawrence was an assistant keeper at Cana Island from 1893 until 1899. His son Volney filled in for Jesse on occasion and during an illness. The schooner *Windsor* went aground during an autumn gale at Cana on September 30, 1893. The crew of the ship spent several days at the lighthouse recovering with the help of the Brown family. (Courtesy DCMM&LPS.)

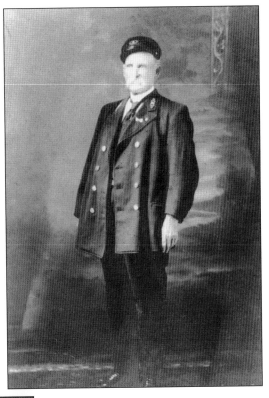

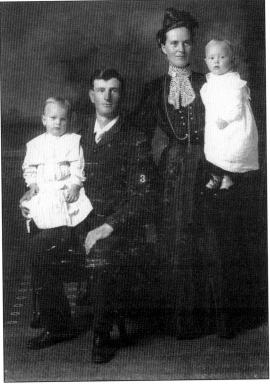

This 1904 picture shows, from left to right, Edward Montgomery Brown, Albert Foster Brown, Lorenza Bavry Brown, and Gerald Louis Brown. Albert and Lorenza had eight children, all of whom were born at the Sturgeon Bay Canal Light Station when Albert served in the Life-Saving Service. Later Albert was in charge of the South Chicago Coast Guard station from 1919 until 1933. (Courtesy DCMM&LPS.)

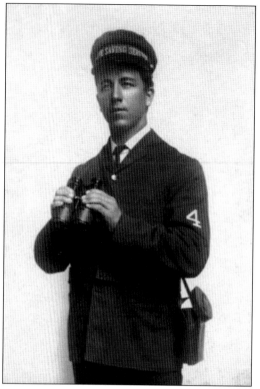

This unidentified member of the Jesse and Hannah Brown family was also in the Life-Saving Service. Records indicate that three of the Brown children, Volney, Lawrence, and Albert, all had careers in the service. This young man was the number four surfman. The nautical heritage of the Brown family was substantial. (Courtesy Jerry Brown.)

Henry R. Bevry was stationed at Cana Island as an assistant keeper from 1899 to 1902 under the supervision of keeper Jesse Brown. Another Bevry family member, Charles, devoted time at three different Door County lights, both Sturgeon Bay Lights and also Pilot Island in the Death's Door strait. It was not uncommon for various family members to also be in the lighthouse service, oftentimes in the same region. (Courtesy DCMM&LPS.)

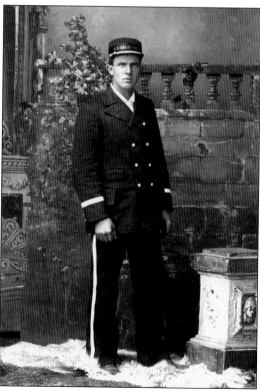

A native of Sturgeon Bay, Henry Bevry had been a watchman at the Sturgeon Bay ship canal prior to coming to Cana Island. Bevry met his future wife Jessie, pictured here, and they were married in 1899 shortly before moving into Cana as newlyweds. The couple spent most of their adult lives together at lighthouses. Interestingly, the Bevry's original Norwegian surname was Baevre and was Americanized to Bavry or Bevry. (Courtesy Tim Harrison.)

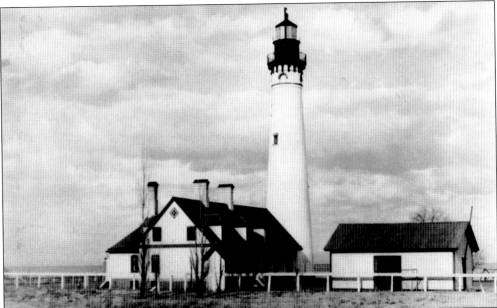

In 1902, after Henry Bevry's assistant keeper appointment at Cana Island, he was transferred to the Wind Point Lighthouse in Racine, Wisconsin. A tall majestic tower much like Cana's, Wind Point would become Bevry's home off and on for several decades. He first served at Wind Point for five years as an assistant and later was promoted to keeper, a post that lasted 32 more years. (Authors' collection.)

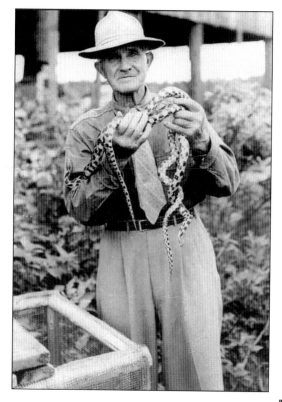

After retirement from the Lighthouse Service, Henry Bevry returned to Door County and became the caretaker of a nature center at Three Springs, east of Sister Bay near Appleport. Very active in his later years, he is pictured in the 1950s at the nature center handling a pair of fox snakes, which are common to that area. (Courtesy FOWP.)

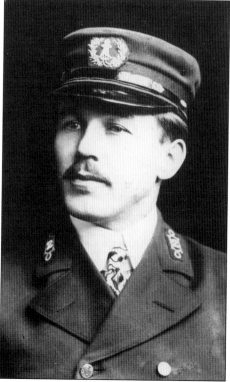

Another lighthouse assistant with keeper Jesse Brown was Reinhart Pfiel. Posing for his official lighthouse portrait, he sports his assistant's uniform. Pfiel was assigned at Cana Island from April 1905 through July 1909. He also served at two other Lake Michigan lights including Kewaunee, Wisconsin, and Grosse Point in Evanston, Illinois. (Courtesy DCMM&LPS.)

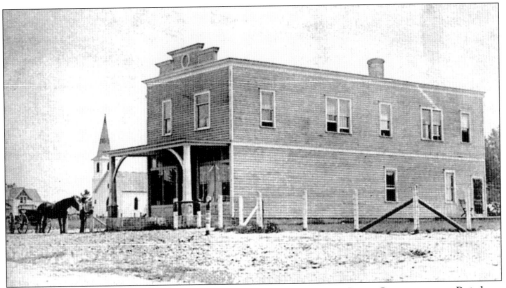

The Pfiel family had its roots in Ellison Bay, a small northern Door County town. Reinhart Pfiel would eventually be involved in a hardware store, an ice-cream parlor, a restaurant, and an amusement center. In this early photograph, around the 1920s, the Pfiel's store has a horse-drawn customer. Pfiel descendants still call Ellison Bay home today. (Courtesy BHPL.)

Pictured here is Anna Johnson, the future wife of Reinhart Pfiel. She lived in Door County in the town of Sister Bay. Anna and Reinhart were married in 1906 and would also have been newlyweds at Cana Island. The Pfiels occupied the second floor of the keeper's quarters at the lighthouse, with the Brown family living on the main first floor. (Courtesy DCMM&LPS.)

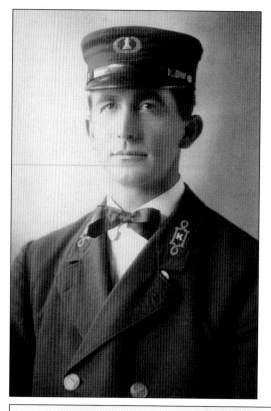

Dressed in his head keeper's uniform, Conrad Andrew Stram was quite the dapper looking young man. Captain Stram was in charge at Cana Island as head light keeper from 1913 to 1918. By all accounts, he kept a very tidy complex. Many of his logbook entries speak of endless painting: the tower, steps in the tower, lantern room, cellar, rooms in the keepers home, outbuildings, boat house, and barn. The day-to-day maintenance at lighthouses was necessary to keep the station running smoothly. (Courtesy DCMM&LPS.)

ADDRESS ALL COMMUNICATIONS TO
LIGHTHOUSE INSPECTOR
MILWAUKEE, WIS.

**DEPARTMENT OF COMMERCE**

LIGHTHOUSE SERVICE

LMS/GHA
154-P

OFFICE OF INSPECTOR, 12TH DISTRICT
MILWAUKEE, WIS.

Keeper, Cana Island Light Station.

Nov. 2, 1917.

Receipt is hereby acknowledged of your letter of Oct. 29, 1917, reporting a visitor at your station, which is contrary to the instructions contained in District Circular Letter No. 101.

You are advised that under the circumstances the regulations will be waived in your case, and you are authorized to give the visitor a permanent residence.

Stoddard
Inspector, 12th District.

The U.S. Lighthouse Service could many times be a bureaucratic, by-the-book organization. Inspectors and other officials were oftentimes feared. This 1917 document deals with the birth at Cana Island of Conrad and Elnora Stram's son Matthew. The inspector must have possessed a good sense of humor, however, and grants residence for their new "visitor" to stay at Cana Island permanently. (Courtesy Rick Stram.)

Pictured here is the Moritz Weiss Sr. family, around 1900. Seen from left to right are (first row) mother Agnes, Ann, Catherine (standing above Ann), Agnes, and father Moritz Sr.; (second row) Mary, Joseph, Fred, Moritz Jr., and Harriet. Interestingly, this Austrian family used the names Moritz and Agnes several times. Besides the two Moritzes and Agneses, Moritz Jr. married another Agnes. There was a daughter-in-law by the name of Agnes, too. (Courtesy Doris Rockwell.)

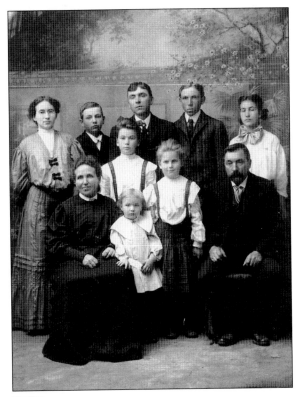

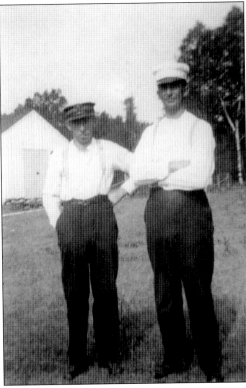

Assistant keeper Moritz Weiss Jr. (left) is pictured on Cana Island with keeper Conrad Stram near one of the island's several barns, around 1915. Weiss was an assistant under keepers Stram and Oscar Knudsen at Cana Island from 1911 through 1919. Stram and Weiss would eventually take different paths, however. Weiss reentered family enterprises while Stram became master of the Lansing Shoal Lightship. (Courtesy Louie and Rosie Janda.)

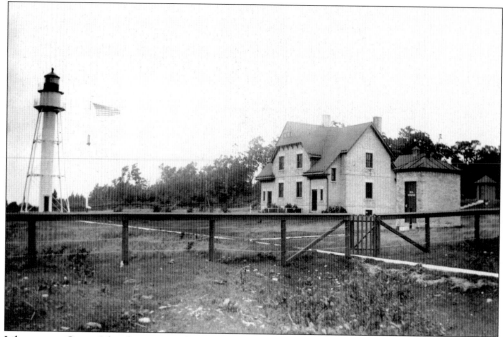

Like many Cana Island assistant keepers, Moritz Weiss also tended to other Door County lighthouses during his lighthouse career. Prior to coming to Cana Island, Weiss was an assistant keeper at the Plum Island Range lights. Fifteen miles to the northeast of Cana, Weiss served on Plum Island in the dangerous Porte des Morte passage from 1907 to 1911. He received a $30 per year raise, to $480 annually, when he transferred to Cana. (Courtesy Steven Karges.)

Moritz Weiss Jr. is pictured here with his wife, Agnes Pedersen Weiss. They were married on June 12, 1908, in Sister Bay. Weiss resigned from the Lighthouse Service in 1919 after his eight years on Cana Island. He became involved again in his family's Baileys Harbor blacksmith business and farm. The Weiss family was one of several families that anchored the early Baileys Harbor community. (Courtesy Doris Rockwell.)

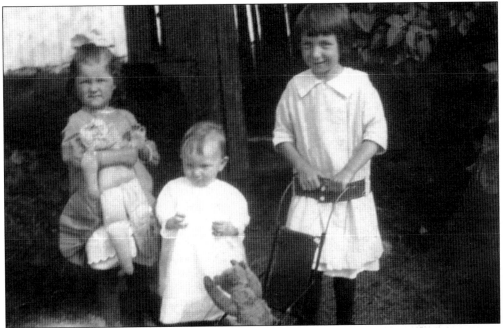

Many children called Cana Island home. Moritz Weiss Jr. came from a family of eight children, and he and his wife, Agnes, had five: Beulah, Ruby, Donald, Eugene, and William (Billy). This c. 1917 photograph at Cana Island shows, from left to right, Marguerite Stram (daughter of keeper Conrad Stram), Ruby Weiss, and her sister Beulah Weiss. A doll, teddy bear, and stroller were everyday playthings. (Courtesy Doris Rockwell.)

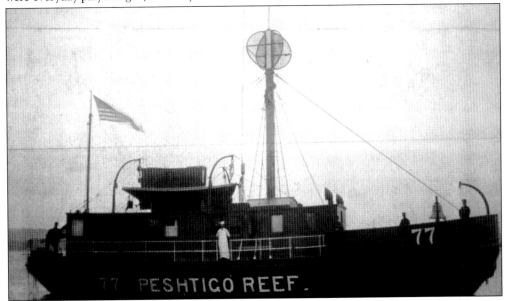

Conrad Stram had a distinguished lighthouse career. Prior to his time at Cana Island, he was assigned to several other lighthouses and two floating lighthouses known as lightships. In 1908, Stram became the commander of the *Peshtigo Reef* lightship pictured here. A shallow reef in the bay of Green Bay off the city of Peshtigo, Wisconsin, was marked by this vessel. (Courtesy Peshtigo Historical Society.)

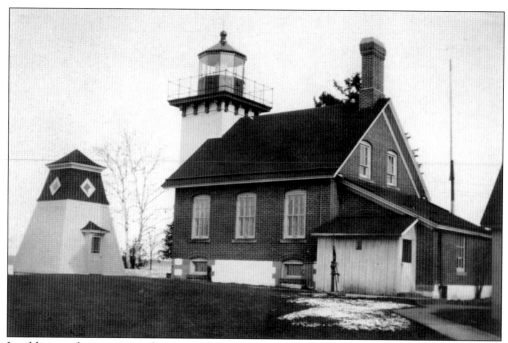

In addition to being stationed at Cana Island, the Sturgeon Bay Canal Station, and at several other Great Lakes lighthouses and lightships, Conrad Stram's final post was again in Door County. He had the distinction of being the final civilian keeper at the Sherwood Point Lighthouse, situated at the western end of Sturgeon Bay. Captain Stram's lighthouse career ended at Sherwood Point in 1945 and totaled 42 years. (Courtesy DCMM&LPS.)

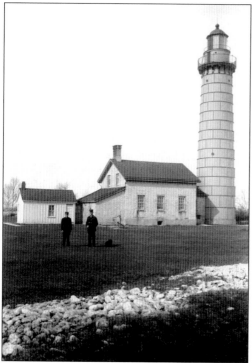

Keeper Oscar H. Knudsen (right), pictured in this classic 1920s photograph, stands in the yard at Cana Island with assistant keeper John Hahn and a dog. Knudsen was head keeper at Cana for six years, 1918 through 1924. He is credited with rescuing several people from the wooden steamer *Frank O'Connor*, which caught fire off Cana Island in 1919. Incidentally, the Norwegian name Knudsen has also been spelled Knudson, Knutsen, Knutson, and so on. (Courtesy DCMM&LPS.)

During his time at Cana Island, Oscar Knudsen worked with eight different assistants, more than any other head keeper. Nearly all the assistants under Knudsen had very short tenures, usually only a few months. It is not known the reason for so many assistants moving on. Knudsen and his assistants were responsible for the stone walls that still can be seen today circling portions of the lighthouse grounds. (Courtesy Louie and Rosie Janda.)

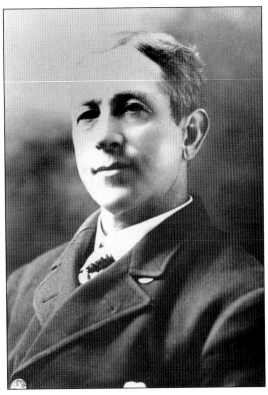

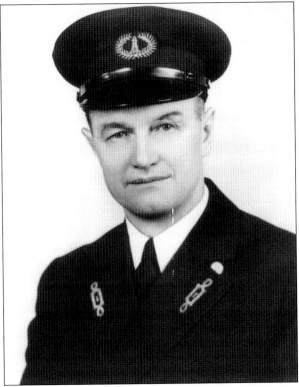

Charles (Charlie) Linsmeier served at Cana in 1922 for only eight months, but his lighthouse career totaled 34 years. Linsmeier later worked at the South Chicago Harbor Light, the North Point Light in Milwaukee, and at Rawley Point, near Two Rivers, Wisconsin. Linsmeier's daughter Vivian Langer recalls as a child she felt fortunate growing up in a lighthouse family, as they saw dedication to duty everyday. She still cherishes her early lighthouse years. (Courtesy Vivian Langer.)

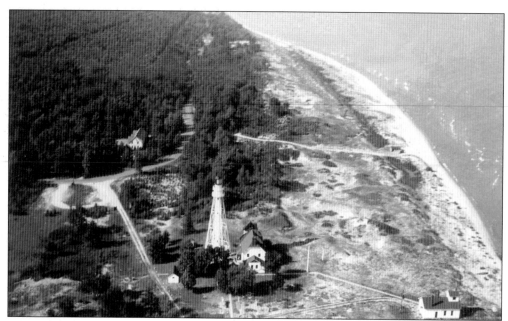

Cana Island happened to be Charlie Linsmeier's shortest tour of lighthouse duty. His final and longest residence was at the Rawley Point Lighthouse, also known as the Twin River Point station, outside of Two Rivers, Wisconsin. Linsmeier was assigned to Rawley Point in 1941 after first assistant Alvin Anderson died of a heart attack there. Linsmeier received several commendations for the high efficiency he maintained at this lighthouse. (Courtesy Vivian Langer.)

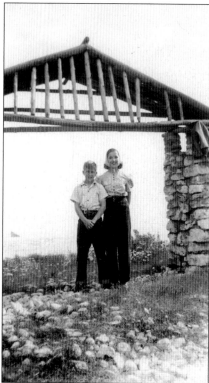

Chuck and Vivian Linsmeier stand beneath a wooden archway during a visit to Cana Island in 1941. Their father, Charles, was an assistant keeper under keeper Oscar Knudsen in 1922. Today portions of the stone pillars still stand, but the wooden framed archway has long since vanished. Currently the stone supports will guide visitors out the south side of the lighthouse grounds to the shallow rock ledges surrounding Cana Island. (Courtesy DCMM&LPS.)

This photograph (around 1900) of Henry and Eve Hendrick Gattie would have been taken while Henry was keeper of the Baileys Harbor Range Lights. He served there for 26 years. When the Range Lights were fully automated, their care was assigned to the keepers of the Cana Island Light. Henry was transferred there. (Courtesy Kenneth W. Robertson.)

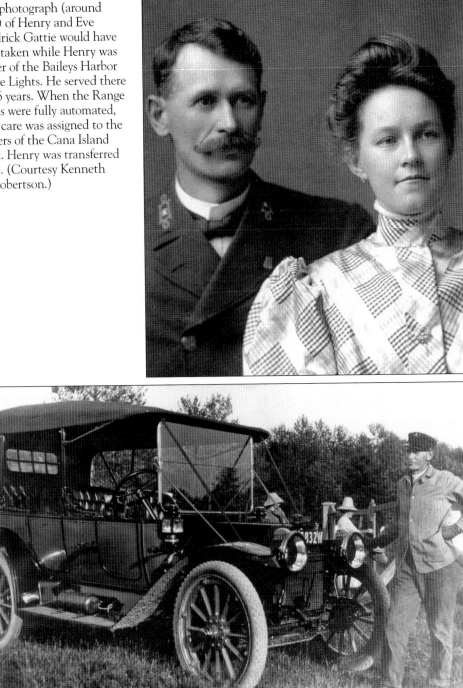

While Henry Gattie was stationed at Cana Island, keeper Oscar Knudsen's logbooks record that on September 25, 1922, they "repaired the barn door and slide to get Mr. Gattie's car in the barn." Further logbook entries from October 1922 document Henry and Eve Gattie traveling to Two Rivers for several days. Henry Gattie was often seen around Door County in various vehicles, often sporting his keeper's hat. (Courtesy Kenneth W. Robertson.)

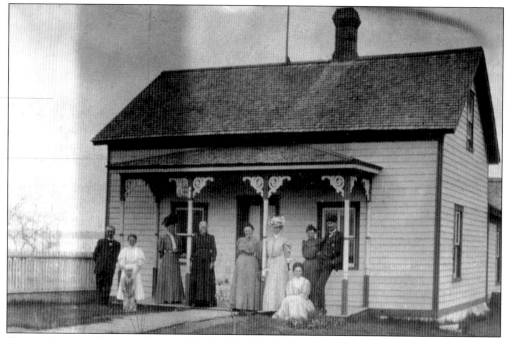

Henry Gattie and his family were fixtures in the life of Baileys Harbor. Pictured at the Adam Hendrick home on Main Street around 1906 are, from left to right, Gus Pfeffer, Louise Dresser (née Pfeffer), Kenneth Robertson, Nellie Nelson, Ernestina Hendrick, Gustie Pfeffer, Eve Gattie, Anna Hendrick, Nellie Robertson, and Henry Gattie. This home still stands in Baileys Harbor and is owned by a relative of the Gattie family. (Courtesy Kenneth W. Robertson.)

The Samuel Hanson family is shown in this c. 1913 picture. The Hanson children, from left to right, are Edgar, Doris, Sadie, and Clifford. Standing behind their children are parents Mary and Samuel. Samuel Hanson would serve as an assistant at Cana Island for less than five months in 1923 while Oscar Knudsen was keeper. (Courtesy DCMM&LPS.)

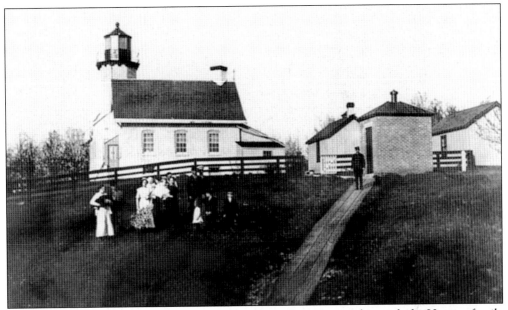

While stationed at Chambers Island from 1909 through 1922, tragedy struck the Hanson family multiple times. Samuel Hanson's wife, Mary, suddenly died in 1914. Later their youngest son, Edgar, perished after his appendix burst, and soon afterward their oldest son, Clifford, drowned after falling through winter ice. Samuel Hanson's heart may not have been in his short tenure at Cana Island after all these misfortunes. (Courtesy BHPL.)

This 1884 treasury department document lists Clifford Sanderson's 1884 assistant keeper annual wage at Cana Island of $400. Sanderson is one of a small group of Cana keepers that was an assistant there and then later became head keeper. He assisted his father, William Sanderson, from 1884 to 1889. Thirty-five years later, from 1924 to 1933, Clifford was placed in charge at Cana Island. (Courtesy DCMM&LPS.)

Division of Appointments.
Form 13.

**Treasury Department,**

OFFICE OF THE SECRETARY,

*Washington, D. C., August 21, 1884.*

*Mr. Clifford W. Sanderson,*

*Care of the*

*Light-House Board,*

*Sir:*

*Having been examined and found qualified, you are hereby appointed Assistant Keeper of the Light-House at Cana Island, Wisconsin, at a Salary of four hundred dollars per annum*

*I am, very respectfully,*

Chas E Coon

*Acting Secretary of the Treasury.*

RECEIVED
AUG 22 1884
LIGHT HOUSE BOARD

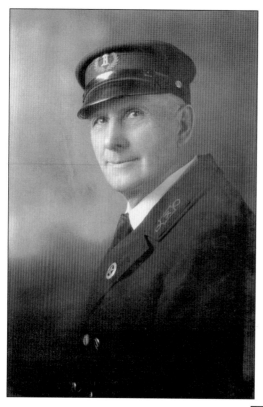

The gentleman pictured here with the gleam in his eye is keeper Clifford William Sanderson. The star on his lapel below the head keeper's insignia is called an efficiency star. Stars and pennants were awarded to light keepers to promote efficiency and friendly rivalry. Inspector's stars were replaced by commissioner's stars if the keeper received recognition three years in a row. (Courtesy Edgar Bletcher family.)

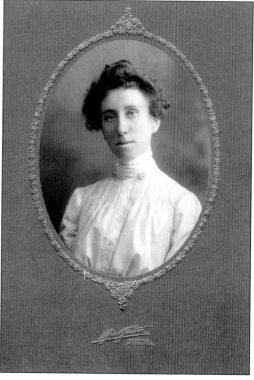

Hedwig Sanderson, Clifford Sanderson's wife, is pictured here. Clifford was a bachelor until he married Hedwig Oertling of Milwaukee in February 1913. Hedwig, called Hattie, spent many years at Cana Island. Hattie died at age 63 in 1940, two years prior to her husband. Both are buried in Sturgeon Bay's Bayside Cemetery, alongside Clifford's parents, keeper William and assistant keeper Sarah Sanderson. (Courtesy Edgar Bletcher family.)

The bulk of Clifford Sanderson's lighthouse years were spent in Door County. After one year at the Cedar River Light in Michigan, Sanderson returned to Door County at the Dunlap Reef Range Lights in Sturgeon Bay. A shallow bay passage, Dunlap Reef was Sanderson's home for 34 years. Sanderson's Door County lighthouse service totaled nearly 50 years. He ended his distinguished career at Cana Island on July 1, 1933. (Courtesy DCMM&LPS.)

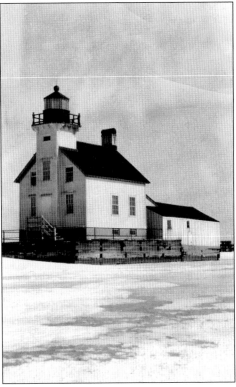

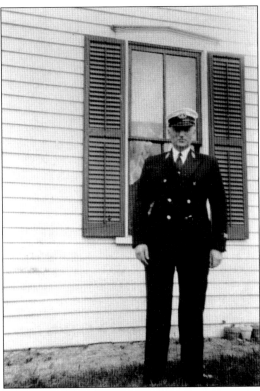

Theodore Grosskopf was assistant keeper under Oscar Knudsen until April 1924, when Knudsen was transferred to the Grosse Point Lighthouse in Evanston, Illinois. Clifford Sanderson then became keeper at Cana. During these years, the keepers at Cana were also responsible for checking the gas pressure at the automated Baileys Harbor Range lights. Grosskopf was transferred later to the Sturgeon Bay Canal Station in 1932. (Courtesy DCMM&LPS.)

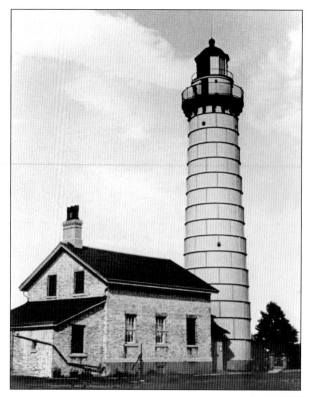

Ross Wright became assistant keeper at Cana Island in 1932 under Clifford Sanderson. Prior to his Cana Island years, Wright serviced the Manitowoc Breakwater Light, where he had spent over a decade. The logbook from May 1932 states "painted outside of dome on tower." This 1930s photograph shows the small-figured Wright leaning on the railing outside the top of the Cana tower. (Courtesy Steven Karges.)

Ross Wright married Grace Kellogg in 1910. This c. 1939 photograph shows Ross and Grace relaxing at Cana Island. Grace's health began to deteriorate several years earlier, and Helen Anderson was employed as housekeeper for the Wrights. Grace suffered a stroke during dinner at Cana in August 1939 and died later that evening at the lighthouse. (Courtesy DCMM&LPS.)

This *c.* 1939 photograph shows keeper Ross Wright's mother, Ross Anne, seated in the yard at Cana Island. Behind her are her sons Jay (left) and keeper Ross Wright. The Wrights often had family members staying on the grounds. Ross Wright's parents had accommodations either in the main lighthouse dwelling, in another building on the grounds, or in a mobile trailer. (Courtesy DCMM&LPS.)

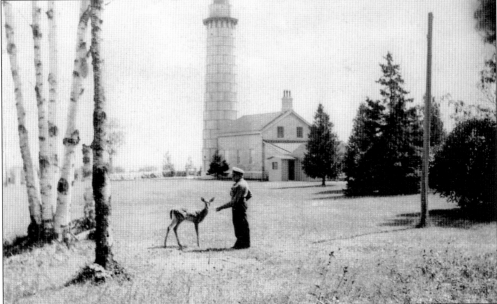

Ross Wright's logbook entry, dated August 31, 1933, states "Got deer from State game farm." The Wrights did have a pet deer named Oscarina that roamed the grounds at Cana Island. It is not known if this tame appearing deer is the one referred to. The deer clearly was not concerned with the friendly Ross Wright but seems more interested in the handout or perhaps the photographer. (Courtesy DCMM&LPS.)

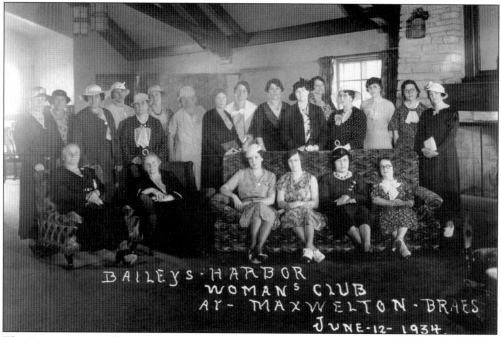

This June 12, 1934, photograph shows members of the Baileys Harbor Women's Club. Taken in the spacious banquet hall of the Maxwelton Braes Resort in Baileys Harbor, these ladies met here regularly. Grace Kellogg Wright, wife of keeper Ross Wright, is standing third from the left. Cana Island life was not confined to only lighthouse duties. Social get-togethers for both men and women were commonplace. (Courtesy BHPL.)

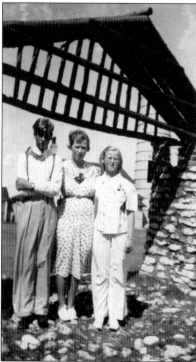

Helen Anderson, center, is flanked by her son Gerald on her left and daughter Alethea on her right, around 1939 at Cana Island. Helen served as a housekeeper at the lighthouse for the Wrights when Grace's health began to fail. Later she also helped Ross in Sturgeon Bay after Grace's death and prior his retirement. Helen recalled fond Cana memories. (Courtesy DCMM&LPS.)

During her housekeeper days at Cana Island, Helen Anderson lived in a trailer on the island that was nestled near the lighthouse in a grove of pine trees. Helen's daughter Alethea is pictured in 1939 entering the trailer. This vehicle was the talk of the area, being that it was such an uncommon sight in those days. (Courtesy DCMM&LPS.)

As some of the lighthouse duties became more automated in the 1930s, there was time for other activities on Cana Island that were not lighthouse related. Here assistant keeper Ross Wright on the left is pictured, around 1932, enjoying hunting with Edgar Bletcher, a nephew of keeper Clifford Sanderson, along with a companion dog. It is unknown if the hunters had any luck. (Courtesy Edgar Bletcher family.)

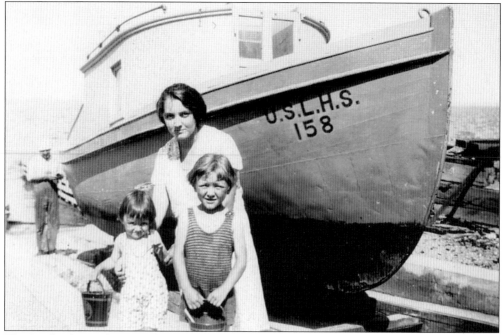

The Michael Drezdzon family, pictured next to U.S. Lighthouse Service boat No. 158, was stationed at Green Island Light around 1931. Pictured with their mother, Susan, are June on the left and Virginia on the right. Michael Drezdzon stands in the background. The boat was used to travel the five miles to Marinette, Wisconsin, for provisions. The family's next home was Cana Island. (Courtesy Virginia Smiddy.)

Susan Scotten married Michael Drezdzon in New York City in 1924. While their given names were Michael and Susan, daughter Virginia Drezdzon Smiddy recalls her parents being called Tommy and Bessie. Susan may have found life in the lighthouse service and on Cana Island spartan and different than what she was used to in New York. Virginia remembers that her parents felt fortunate to have the steady lighthouse job. (Courtesy Virginia Smiddy.)

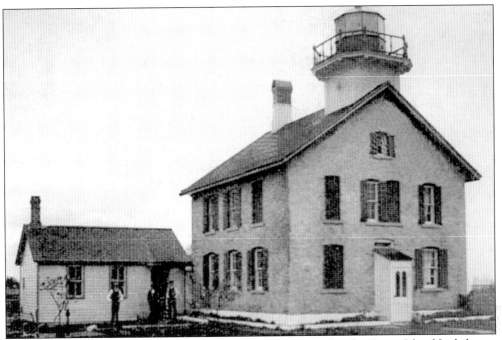

Before coming to Cana Island, Michael Drezdzon was stationed at the Green Island Lighthouse as assistant keeper for two years, 1931 to 1933, under keeper Alfred Cornell. When Green Island was automated in 1933, Drezdzon was transferred to Cana Island. Michael's daughter, Virginia, recalls the abundance of lilac bushes and a cherry tree on Green Island and happy-go-lucky days spent playing on the island. (Courtesy Francis and Doris Cornell.)

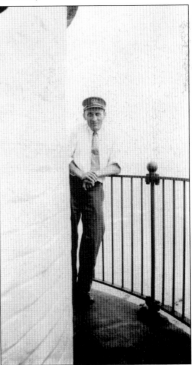

In July 1933, Michael Drezdzon was transferred to Cana Island as assistant keeper alongside keeper Clifford Sanderson. The summer months were packed with the duties of endless maintenance and painting the interior and exterior of the station. The keepers also kept track of the number of visitors taken to the top of the tower that year, 1,871. (Courtesy Virginia Smiddy.)

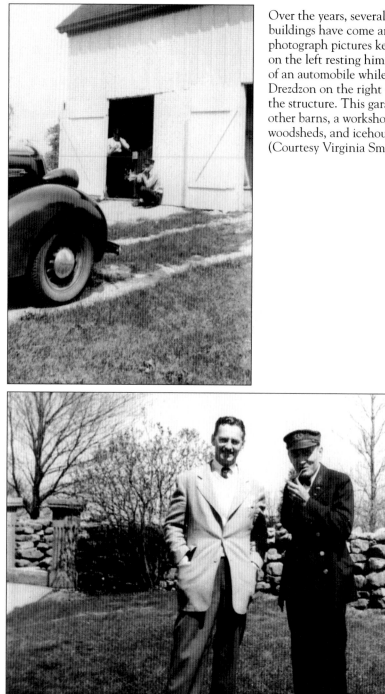

Over the years, several Cana Island buildings have come and gone. This c. 1935 photograph pictures keeper Ross Wright on the left resting himself on the bumper of an automobile while assistant Michael Drezdzon on the right takes a break against the structure. This garage, as well as several other barns, a workshop, smoke house, woodsheds, and icehouse, no longer exists. (Courtesy Virginia Smiddy.)

Heine, of the musical group Heine and the Grenadiers, poses with pipe-smoking Michael Drezdzon on the grounds at Cana Island (around 1936). Drezdzon's daughter, Virginia Smiddy, likens bandleader Heine to Lawrence Welk. Virginia stated that "Heine was very famous." It must have been an honor that Heine was friends with the Drezdzons and took time to come and visit with them. (Courtesy Virginia Smiddy.)

In 1939, the Lighthouse Service merged into the Coast Guard. Donald Langohr, the coast guardsman pictured here around 1942, was sent to Cana Island as assistant keeper under keeper Ross Wright. Michael Drezdzon also remained at Cana Island when Wright retired in June 1941. Langohr helped build the entryway on the rear of the lighthouse that still stands. He also trained military personnel on the island when the United States entered World War II. (Courtesy Orv Langohr.)

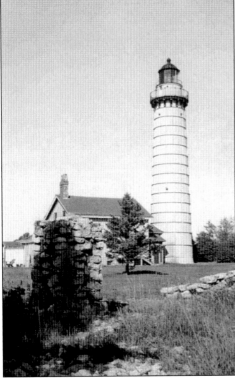

The Coast Guard leased the Cana Island complex starting around 1945. For 25 years, the Ralph McCarthy family rented the lighthouse and spent their summer months there. Little is known of the McCarthy years at Cana. The Coast Guard removed a large barn, the boathouse and pier, oil tanks, and a summer kitchen during this time. Also, a side entrance from an original window was put in place near the tower. (Courtesy WMM.)

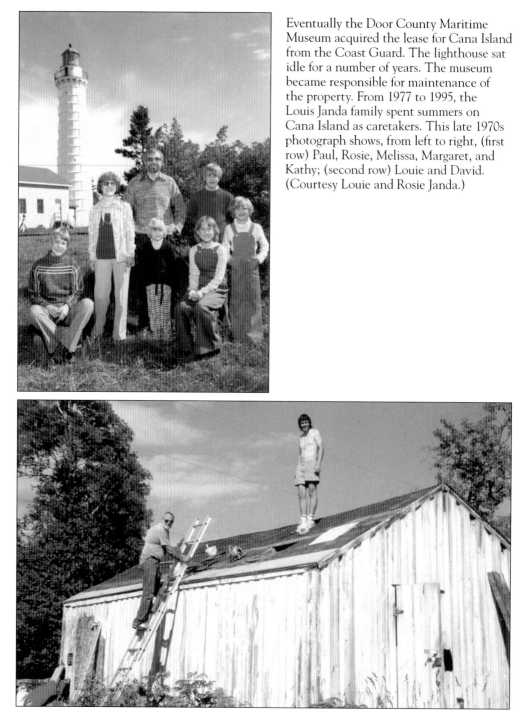

Eventually the Door County Maritime Museum acquired the lease for Cana Island from the Coast Guard. The lighthouse sat idle for a number of years. The museum became responsible for maintenance of the property. From 1977 to 1995, the Louis Janda family spent summers on Cana Island as caretakers. This late 1970s photograph shows, from left to right, (first row) Paul, Rosie, Melissa, Margaret, and Kathy; (second row) Louie and David. (Courtesy Louie and Rosie Janda.)

The Cana Island Lighthouse was a mess when the Jandas first arrived. All the buildings needed attention. There were broken windows, holes in walls, rotted floors, no potable water, peeling paint and wallpaper, no furniture, no sanitation facilities, no tools, and no maintenance equipment. Chimney flues were blocked. Holes in the soffits allowed birds and bats in. Here Louie (left) and Paul Janda repair the barn. (Courtesy Louie and Rosie Janda.)

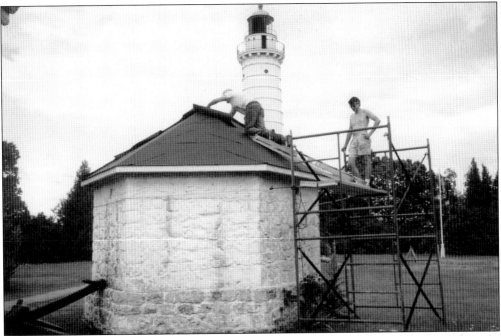

"As soon as we moved in, the magic of the place took over," the Jandas said. The family brought in furniture and tools. The Baileys Harbor Women's Club paid for telephone service. Electricity was installed in the house for the first time, but the Jandas did not bring a television. Their drinking water was carried in. Here Louie (left) and Paul Janda repaired the roof on the oil house. (Courtesy Louie and Rosie Janda.)

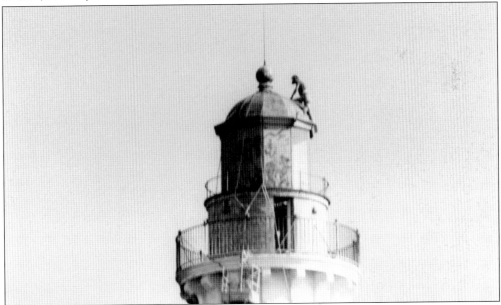

While the Janda family was involved with the day-to-day upkeep of Cana Island, occasionally the museum would need to contract out certain maintenance work. In the 1980s, a crew was hired to refurbish the outside of the light tower. This man, with the assistance of pulleys and ropes, reaches Cana's pinnacle, the lantern dome. (Courtesy Louie and Rosie Janda.)

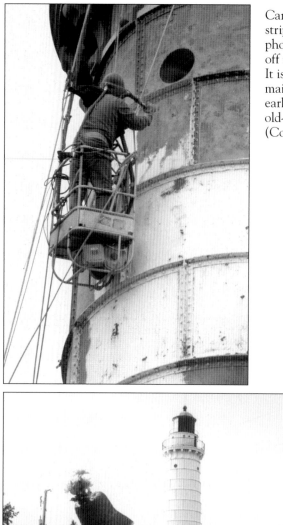

Cana's metal tower needed to be completely stripped down to bare iron. This c. 1980s photograph shows a worker sandblasting off rust and the many layers of old paint. It is hard to imagine how some of this maintenance was done years ago by the earlier keepers. They probably used good old-fashioned toil and elbow grease. (Courtesy Louie and Rosie Janda.)

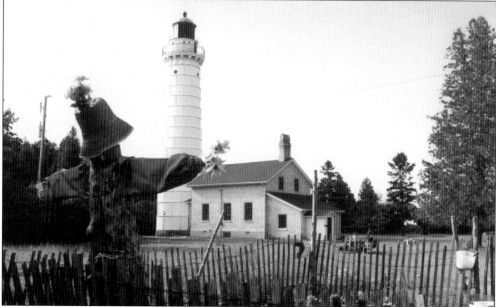

Aside from all the repairs that were necessary, Rosie Janda recalled picnics, sitting around the fire at night, and fresh lake breezes. The Jandas witnessed storms that washed rocks as big as one's head through the walkways. They planted flowers around the house and stone walls. The scarecrow, named Norma, watched over the vegetable garden. The island was open daily from 10:00 a.m. to 5:00 p.m. (Courtesy Louie and Rosie Janda.)

The Jandas definitely are people persons. They served a family fish boil every autumn. During their tenure as caretakers, the Jandas recall one of their favorite highlights: the 125th anniversary of the station, celebrated in 1994. Over 100 descendants of keepers of Cana Island helped them mark the event. Stories were shared, and additional friendships were made. (Courtesy Louie and Rosie Janda.)

Rosie Janda significantly added to the knowledge of the day-to-day life at Cana Island by transcribing the keepers' logbooks of 1872 to 1934. Along with some help from a few Cana Island friends and neighbors, Rosie spent several years wading through volumes of material. The compilation and editing allows us to appreciate the dedication of Cana's earliest caretakers. (Courtesy DCMM&LPS.)

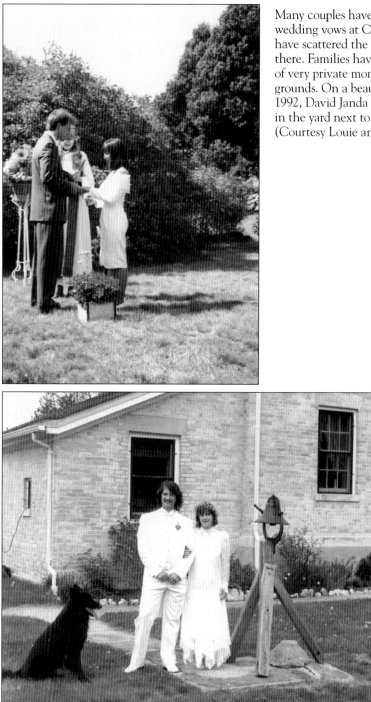

Many couples have exchanged their wedding vows at Cana Island, and some have scattered the ashes of their loved ones there. Families have witnessed a number of very private moments on the lighthouse grounds. On a beautiful summer day in 1992, David Janda weds Kelly Christenson in the yard next to the lighthouse. (Courtesy Louie and Rosie Janda.)

Three of the Janda's children held their wedding receptions at Cana Island. In 1992, Margaret Janda and Bill Smith celebrate their new life together. Margaret wears the wedding dress that her mother, Rosie, made for her. The Janda's dog, Sebastian, looks on. Incidentally, they happen to be standing at the location of an earlier well and water pump. (Courtesy Louie and Rosie Janda.)

*Four*

# DAILY LIFE
## EVERYDAY OCCURRENCES
## AND SPECIAL EVENTS

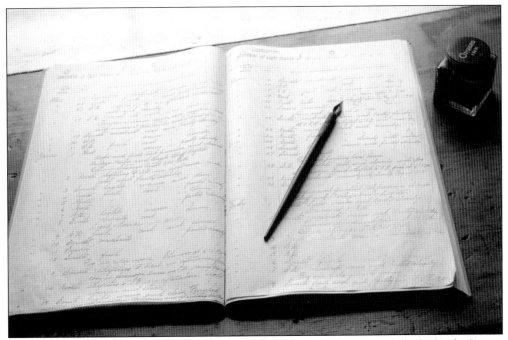

Government regulations required lighthouse keepers to maintain a daily logbook. It was considered an official lighthouse service document and record of the station. Entries were to be written in by lighthouse personnel only. The opened book consisted of two pages, a left and right side, and the two pages encompassed a month's time. Much of the known day-to-day life at Cana Island was recorded here. (Authors' collection.)

UNITED STATES LIGHT-HOUSE ESTABLISHMENT.

INSTRUCTIONS

TO

# LIGHT-KEEPERS AND MASTERS OF LIGHT-HOUSE VESSELS.

## 1902.

BY AUTHORITY OF THE LIGHT-HOUSE BOARD.

WASHINGTON:
GOVERNMENT PRINTING OFFICE.
1902.

The first *Instruction to Light-Keepers* dates to the 1850s. Pages and pages of specific instructions, dozens of plates illustrating various types of lighthouse equipment, and an extensive index were included in this document. It was considered "the Bible" of the facility and a formal government manuscript. It is filled with regulations, rules, and requirements. Everything from aprons to be worn when cleaning lamps to wreck reports by keepers is thoroughly covered. (Courtesy GLLKA.)

**JOURNAL of Light-house Station at** *Dana Island*
*Wm A. Sanderson Keeper*

| 1875 MONTH. | DAY. | RECORD OF IMPORTANT EVENTS AT THE STATION, BAD WEATHER, &c. |
|---|---|---|
| Nov. | 13 | Pilot-Island Light seen bright |
| " | 14 | " " " " |
| " | 15 | " " " " |
| " | 16 | " " " at intervals |
| " | 17 | " " " " bright |
| " | 18 | Heavy Gale Wind South East with Snow |
| " | 19 | Pilot-Island Light seen bright and |
| " | 20 | " " " " " |
| " | 21 | " " " " dim |
| " | 22 | Heavy Gale Wind South and Snowing |
| " | 23 | Pilot-Island Light seen bright & Clear at |
| " | 24 | " " " " " |
| " | 25 | " " " " " |
| " | 26 | " " " " " |
| " | 27 | Wind East Very thick and Snowing |
| " | 28 | Heavy Gale from West & N W. and Very |
| " | 29 | Snowing with a fresh Breeze from N W |
| " | 30 | " " " " " S E |
| Dec | 1 | Wind North Mild Pilot-Island Light seen Bright & Clear |
| " | 2 | " " " " " " |
| " | 3 | Damp & Foggey " " " Not Seen |
| " | 4 | " " " " " |
| " | 5 | " " " " " |
| " | 6 | Pilot-Island Light seen bright & Clear at intervals |
| " | 7 | " " " " " " |
| " | 8 | " " " " " " |
| " | 9 | " " " " " " |
| " | 10 | " " " " " " |

Logbook entries could include very simple things such as weather conditions, wind direction, or the passing of ships in the distance. The daily log might also be quite detailed as with storms, shipwrecks, and rescue efforts. Sometimes historical events such as the Fourth of July or the death of a United States president or celestial occurrences would become forever penned in the book. (Courtesy DCMM&LPS.)

In addition to everyday climate observations, unusual celestial events sometimes made their way into the logbook. The entry for May 1, 1910, by keeper Jesse T. Brown simply states, "Hailey's Comet seen East 3:30 a.m. J.T.B. May 1st." Later that month, on May 26, Brown also writes, "Comet showers bright." (Courtesy Mount Stromlo Observatory/Galaxy Picture Library.)

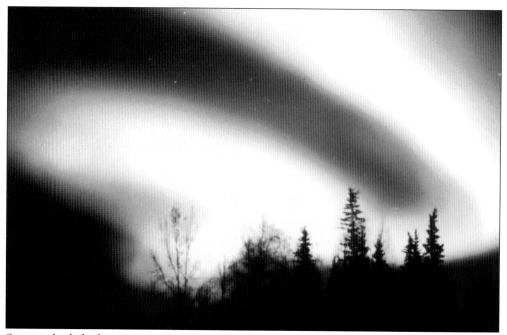

Spectacular lightshows occurred at Cana Island when the northern lights put on their displays. Light keeper Clifford Sanderson made the following notation on September 24, 1925, "Very bright Northern lights at 2 a.m." Picture a clear Door County night, countless stars framed by towering trees, the aurora's colors dancing and flickering with the Cana tower and lantern as a backdrop. The keepers must have been in awe. (Courtesy NOAA.)

Much of the written word in the Cana Island logbooks is not exciting reading. The style of the entries varied greatly depending on the keeper. Some were better record keepers than others. A number of accounts are very detailed while others are meager. Keeper Oscar Knudsen witnessed a rare eclipse of the sun. His logbook of September 10, 1923, is concise: "Eclipse of sun at 2pm." (Authors' collection.)

On January 20, 1901, at 11:30 p.m., keeper Jesse Brown reports in his log entry, "A duck went through the plate glass window and chipped and scratched the lens." Several other entries years later also chronicle ducks hitting the plate glass windows in the lantern room and being killed. In 1922, another duck went through the glass window and was still alive when found! (Authors' collection.)

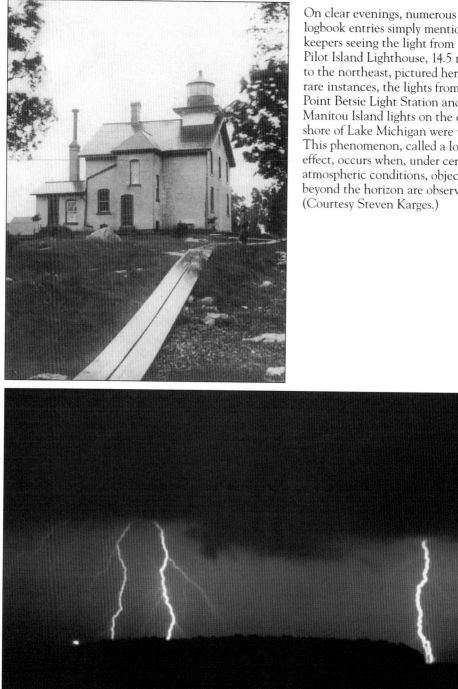

On clear evenings, numerous logbook entries simply mention the keepers seeing the light from the Pilot Island Lighthouse, 14.5 miles to the northeast, pictured here. In rare instances, the lights from the Point Betsie Light Station and the Manitou Island lights on the eastern shore of Lake Michigan were visible. This phenomenon, called a looming effect, occurs when, under certain atmospheric conditions, objects beyond the horizon are observed. (Courtesy Steven Karges.)

In April 1886, William Sanderson records in the logbook, "Wind northeast heavy gale. Terrific thunder, lightning and rain during the afternoon and night, and tremendous sea rolling in around the dwelling." Years later, in 1933, Sanderson's son Clifford would report lightning striking the telephone line, entering the dwelling, putting two telephones out of commission, and knocking plaster off the walls! (Authors' Collection.)

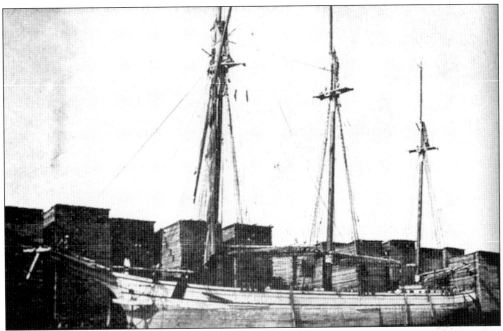

In Cana's earliest days, the shipping season ran from roughly mid-March through late December. Great Lakes ships were primarily constructed of wood at that time so they stayed closer to shore to keep as many lighthouses as possible within view. The 1870 Cana logbooks total 4,862 ships that season, a few steamers but most were schooners similar to the one pictured here. (Courtesy BHPL.)

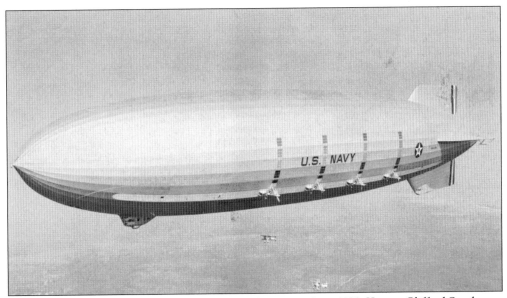

The airship USS Macon was floating over Door County in June 1933. Keeper Clifford Sanderson noted in the logbook that the dirigible passed Cana Island going north and then later south. Lighter-than-air travel vessels were in vogue in America during this time. The Macon had a relatively short life however. Christened in 1933, it crashed off the California coast in February 1935. (Courtesy http://www.pilotfriend.com.)

Many times in its history, including as recently as the 1980s, the limestone causeway has been underwater. The level of Lake Michigan can render the walkway completely dry as is seen today, to knee and thigh deep. The journey to Cana Island is worthwhile either way. During times of higher water, waves can circle around the island and break in a certain pattern along the path. (Courtesy Louie and Rosie Janda.)

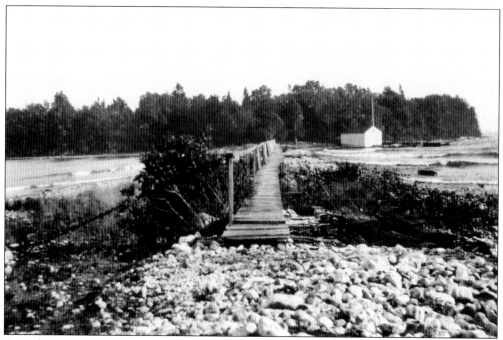

As early as 1882, station records mention a pier and boat landing in front of the lighthouse at Cana. The location of these structures varied. Years ago the footbridge pictured here connected Cana Island to the mainland. A dock and boathouse also were located by the causeway. Many times this bridge and its supporting cribs were rebuilt only to have Lake Michigan have the last word as wind and waves removed them. (Courtesy Clyde Brown.)

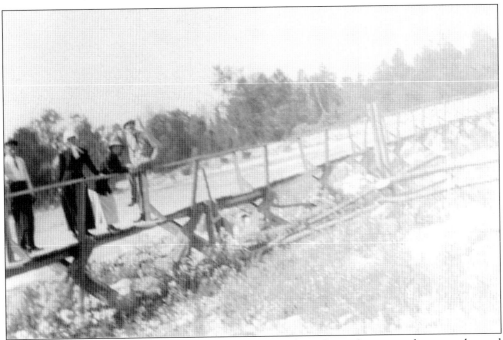

This photograph of the wooden walkway shows people making their way along an elevated portion. The first logbook mention of an artificial wooden bridge across Cana's causeway dates from 1890. Improvements in the early 20th century helped during years of high lake levels. Eventually the causeway became dry, maintenance was a never-ending job, and the walkway was dismantled and burned. (Courtesy Kenneth W. Robertson.)

The early 1920s Cana logbooks tell of keepers and assistants hauling gravel for the causeway during the times of lower water levels. A smoother road was created, and the keepers now had cars. As with the wooden bridges, Mother Nature would always have the final say on the causeway. When the high waters returned years later, much of the gravel and stone was washed away or rearranged. (Courtesy Virginia Smiddy.)

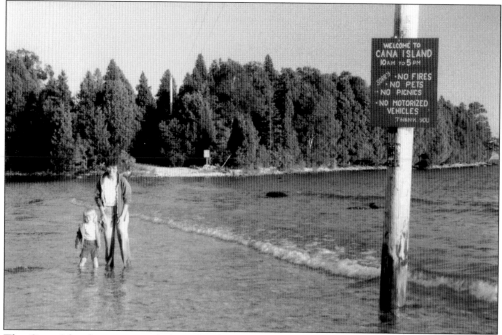

The Cana Island causeway is believed to be natural. Early keepers had difficulties crossing this land bridge at times. High water years at Cana include the 1870s, 1880s, the second decade of the 20th century, and the late 1920s, among others. This 1984 picture shows a mother and her young daughter wading back from a visit to the lighthouse. The wet trek was remembered for many years. (Authors' collection.)

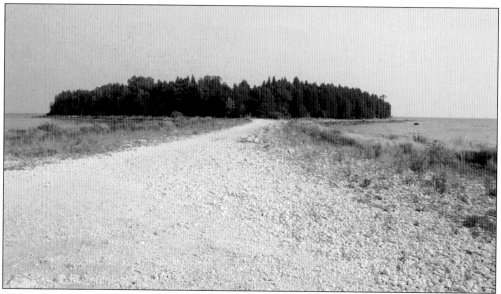

Today Cana Island's causeway is completely dry. The width of this land bridge is currently quite wide. Plants of various species have taken root. It is likely that the cycle of Lake Michigan levels will once again raise the water level and the limestone passageway to and from the lighthouse will become an adventure. Higher lake levels will not stop the true lighthouse enthusiast from visiting Cana Island, though. (Authors' collection.)

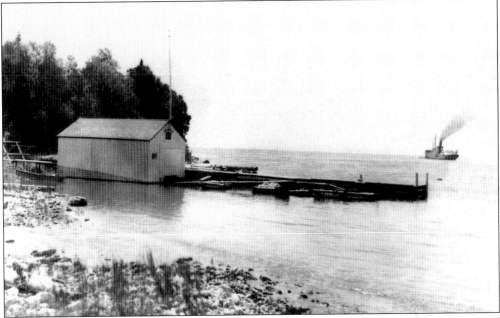

This 1913 picture shows the main boathouse and pier at Cana Island. The structure was located on the western side of the island, south of the causeway seen today. In the distance is a lighthouse tender ship. Tenders would arrive with supplies of fuel, needed equipment, news from the rest of the world, and sometimes the lighthouse inspector, who would scrutinize the station from top to bottom. (Courtesy DCMM&LPS.)

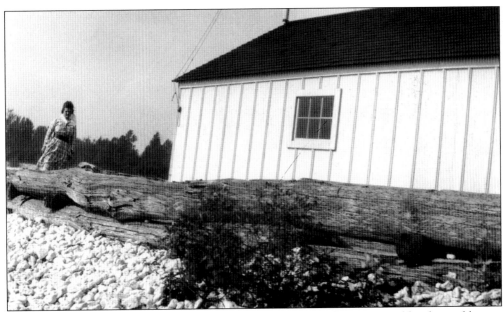

This closer view of Cana Island's boathouse features Donna Brown, granddaughter of keeper Jesse Brown. A reinforced pier constructed of very large wooden timbers and heavy rocks rests alongside the boathouse and would provide some shelter from waves and stormy conditions. These heavy-duty structures nevertheless took a pounding from the lake. (Courtesy Clyde Brown.)

The area immediately surrounding Cana Island is quite shallow with the exception of the southwest corner of the island slightly south of the causeway. This is the location selected for what would become the main and permanent pier. Tons of materials passed through this dock, especially in Cana's early history when roads were poor and automobiles were scarce. Susan Drezdzon poses, around the 1930s, on Cana's wharf. (Courtesy Virginia Smiddy.)

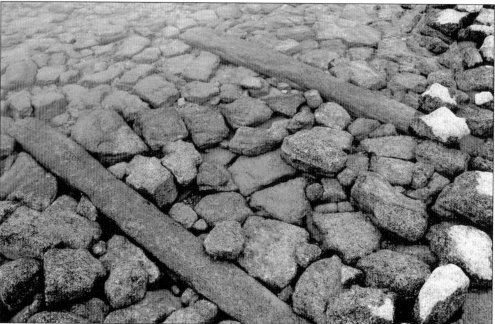

All that remains of Cana Island's massive wooden pier and boathouse are just a few timbers. Pictured here are a handful of submerged logs that still mark their location along the shoreline near the causeway. Sometime after 1945, the Coast Guard dismantled these structures after the lighthouse was automated and there was no need for them anymore. (Authors' collection.)

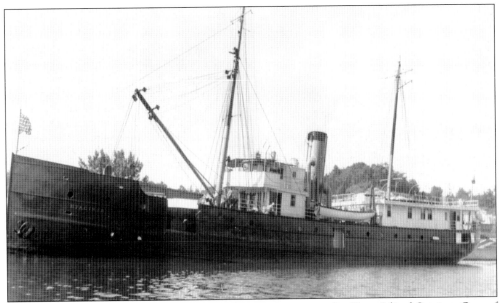

The lighthouse tender ship *Hyacinth* was a frequent visitor to the Cana Island Station. One of its first times stopping at Cana was on June 6, 1910. At this time a new incandescent oil vapor light (IOV) burner for the lens was delivered. Several days later, a Mr. Wrige arrived to install the new lamp. For some reason, tenders were normally named after flowers, shrubs, or trees. (Courtesy DCMM&LPS.)

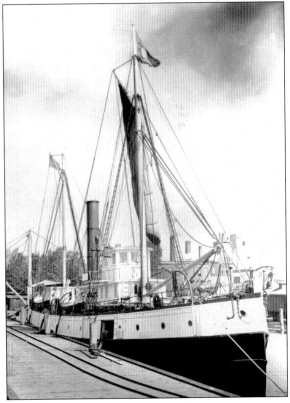

The *Dahlia*, a lighthouse tender ship, was one of the first to stop at Cana Island, on September 29, 1874. "Mr. Crump, the Lampist and Mr. Rainey, the clirk (sic) came and exchanged wick," according to the logbooks of keeper Julius Warren. Other logbook entries record tender ships such as the *Amaranth* and the *Sumac* passing by or being unable to land due to bad weather. (Courtesy DCL.)

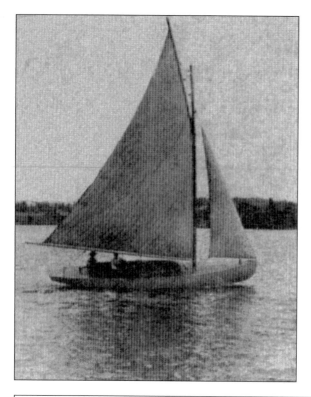

The Cana Island station had some type of boat as early as 1872. Probably the first vessels would have been similar to the small sailboat pictured here. A motorboat was delivered to the lighthouse in July 1910, and other motorboats are mentioned a decade later. Gasoline-powered craft came into the picture around 1918 and improved water travel considerably. (Courtesy Steven Karges.)

For shallow locations like Cana Island, supplies such as food, paint, equipment, and fuel would be off-loaded into smaller boats such as the one pictured here. This style of vessel also ferried lighthouse personnel around Door County. The keeper would greet the tender crew with a small wagon or wheelbarrow and further haul materials to the lighthouse. If the water was deep enough, the tender could directly dock. (Courtesy WIA and Bill Olson.)

Tenders that plied the waters of the Great Lakes had homeports, called depots. Depots were distribution points for the delivery of lighthouse materials. The country was broken down into separate lighthouse districts. The Great Lakes had several of these warehouse locations including Detroit, Benton Harbor, Buffalo, Milwaukee, Toledo, and Duluth, among others. Lighthouse inspectors and superintendents also were stationed at depots. This 1901 photograph depicts part of the Buffalo depot. (NARA photograph courtesy Wayne Sapulski.)

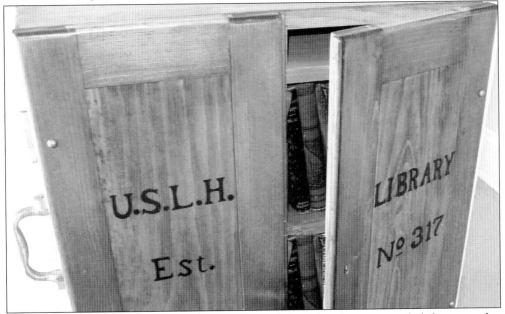

The lighthouse inspector's visit did have a positive side. When he came via lighthouse tender, he would bring traveling "libraries" beginning in the mid-1870s. Each case was identified with a specific number. The cases would vary somewhat in their contents. Light keepers kept lists and communicated their desire for certain specific books. (Courtesy FORI.)

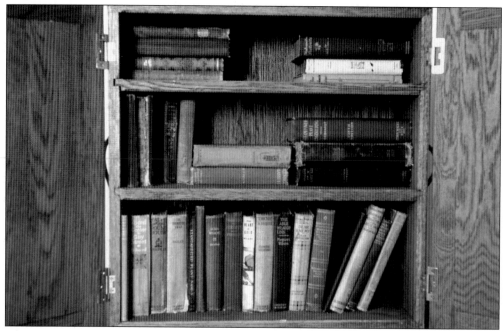

Libraries contained approximately 50 books, with subjects ranging from poetry, science, history, novels, a prayer book, and the Bible. These writings were circulated to light keepers and their families to help pass the time at lighthouses, especially the more isolated ones. These collections were generally issued twice a year and were very sought after. Cana's logs mention deliveries of libraries several times. (Authors' collection.)

Early on, a trip into Baileys Harbor was not the quick, pleasant experience one encounters today. Keepers mostly used a boat to get to town since this was a more efficient means of travel. The main roads to and from Baileys Harbor, such as Bluff Road shown here, were less than perfect and would turn into a sea of mud in the rain. Cana Island Road was not even graded until 1934. (Courtesy Kenneth W. Robertson.)

Mail delivery to Cana Island came in several variations. Initially, mail could arrive via boat from the lighthouse tender or other vessels. Later the mailbox was on the mainland about three miles down rustic roads. Many times the keepers walked to the mailbox. Pictured in this 1912 photograph is a method used in rural Door County, the horse-and-buggy mail delivery. (Courtesy DCL.)

The Baileys Harbor Post Office, pictured here, was over six miles away by land. At the beginning of the 20th century, travel by roadway into town was still difficult at best. Oftentimes the keepers would have gone to Baileys Harbor by boat instead of braving the primitive roads. Sometimes they walked to town. Automobiles and road improvements in the 1930s made trips to the post office much more enjoyable. (Courtesy BHPL.)

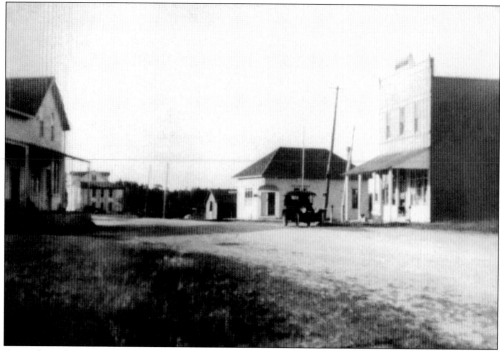

As early as the 1890s, Cana lighthouse personnel traveled to Baileys Harbor at least once a week for various services. In addition to collecting the mail, provisions were purchased. In the early 1900s, the Brann brothers store on the far right was a general store that also sold hardware, implements, and furniture. It was listed in the Baileys Harbor business directory around 1915. (Courtesy DCMM&LPS.)

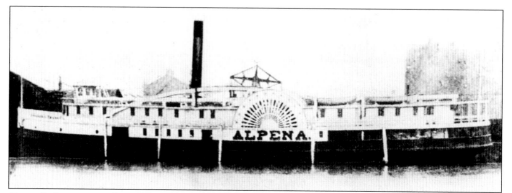

Great Lakes storms have been chronicled for centuries. One of the grandest storms that ever occurred was on October 16, 1880, when the Alpena Gale battered Door County and Lake Michigan. Named after the doomed side-wheeler ship pictured here, Cana Island experienced the brunt of hurricane force winds. Keeper William Sanderson's log entries of October 16 and 17 state, "The Most Severe Storm Ever Known of on the Lake. Seven wrecks in the Vicinity of this Station." (Courtesy DCL.)

Historically the Great Lakes brew storms that rival those of the world's oceans. Tempests on these inland seas can be fierce and deadly. Freshwater waves are less compact than their saltwater counterparts and therefore, have sharper edges than the flow of the ocean. Here a Lake Michigan storm pounds a breakwater lighthouse. (Courtesy Gary Martin Photography.)

Door County has had its share of memorable storms and shipwrecks. Pictured here is the *Otter*, a schooner that grounded off Whitefish Point south of Sturgeon Bay in October 1895. Cana Island snared dozens of vessels that hit its shallow reef area. Fortunately most ships were able to free themselves or were given assistance. Some required extensive repairs; others went on their way not much worse for the experience. (Courtesy DCMM&LPS.)

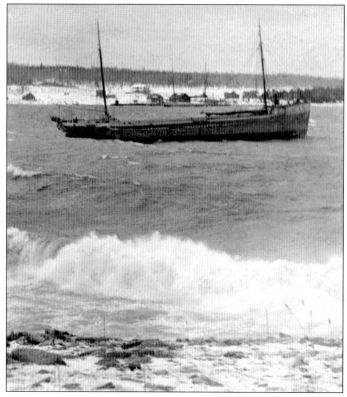

Cana Island felt the effects of another monstrous gale, the "Great storm of 1913," also known as "the Big Blow." More than 250 sailors perished on the Great Lakes from November 7 to 10, 1913. Nineteen ships sank, and dozens more were smashed. Millions of dollars in damages accompanied this fury. This photograph depicts the blizzard buffeting the schooner *Halsted* about near Washington Island in Door County. (Courtesy WIA and Bill Olson.)

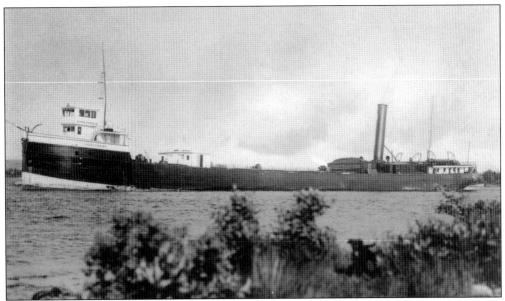

The 300-foot-long steamer *Frank O'Connor* was built in 1892. Steam powered, the ship was on an autumn run on October 2, 1919, from Buffalo to Milwaukee. While chugging south during the afternoon off of Cana Island, a fire developed. The burning steamer was abandoned and eventually sank a few miles off Cana Island. (Courtesy DCMM&LPS.)

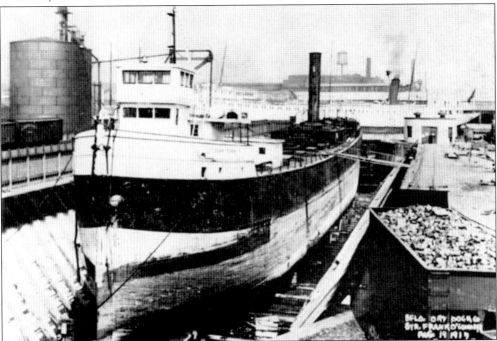

The *Frank O'Connor* was a wooden craft. Carrying a load of coal, the fire spread quickly throughout its hull, and the captain and crew knew immediately that they were in serious trouble. The ship was turned toward shore, but steering the vessel became difficult. Cana keeper Oscar Knudsen and assistant Louis Picor provided help to the *O'Connor*'s sailors with their lighthouse boat. (Courtesy BHPL.)

Years after the sinking of the *Frank O'Connor* off Cana Island, divers illegally removed the ship's anchor. Wrecks in Wisconsin waters are protected by laws that designate them as underwater historical preserves. The anchor was confiscated by authorities, and part of the legal settlement included the provision that the anchor be placed on Cana Island. Today it rests next to the oil house. (Authors' collection.)

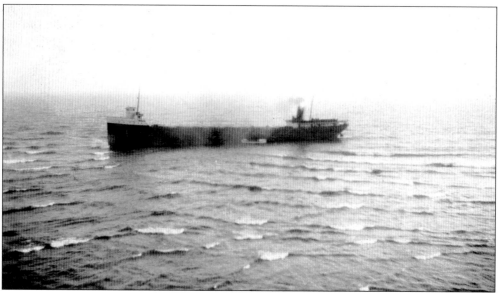

Cana Island's most famous shipwreck occurred on October 3, 1928. Keeper Clifford Sanderson noted in the logbook, "Thick fog on the lake. Steamer M.J. Bartelme ran aground South side of island at 1:00 p.m. Did not know for certain boat was stranded until 3:00 p.m. when fog lifted so could see it." This is the view the keeper would have had from the top of the tower. (Courtesy DCL.)

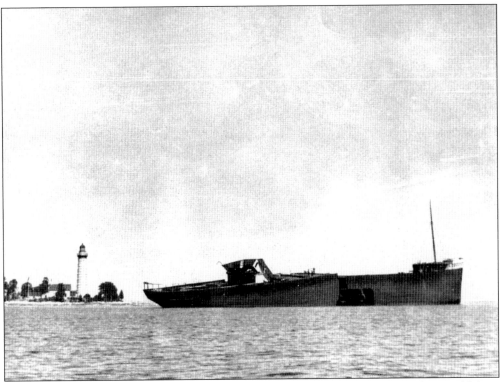

From the day the *Bartelme* was grounded, its crew spent time salvaging what they could from the ship. Keeper Sanderson and assistant keeper Theodore Grosskopf provided assistance by transporting the *Bartelme* crew back and forth in the light station motorboat. Many days they were prevented from working due to heavy seas. On November 5, 1928, the ship broke in two. (Courtesy DCMM&LPS.)

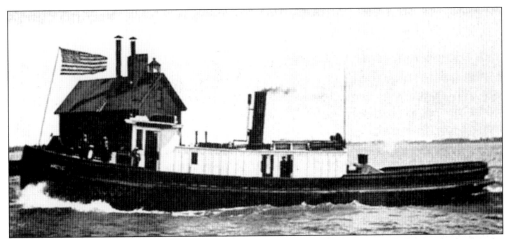

The Baileys Harbor Coast Guard Station was summoned to the *Bartelme* almost immediately. Efforts were undertaken with the assistance of tugboats to try and free the ship. Mother Nature had other ideas, however, and intense southerly winds and waves continued to push the *Bartelme* further aground. The tugboat *Arctic* pictured here was involved in the salvage efforts at the *Bartelme*. (Courtesy BHPL.)

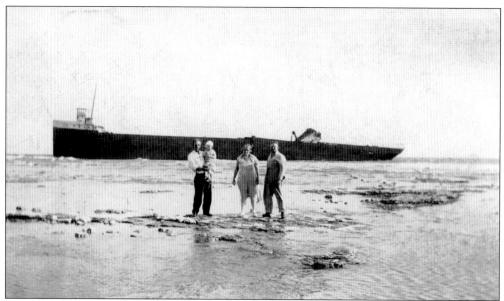

In the five years the wreck of the *M. J. Bartelme* was marooned off Cana Island, salvage efforts continued and many people had their pictures taken near the abandoned hull. Nearly four years after the accident, in July 1932, a gentleman swimming out to the wreck was caught in a current and drowned. His body was recovered the next day by the Coast Guard. (Courtesy DCL.)

Even today remnants of the *M. J. Bartelme* come ashore and can be seen on Cana Island. Some of the metal lines used to salvage the wreck are still visible on the southern side of the island. Larger pieces of the steel ship, now rusting but with rivet holes still evident, lean against Cana's oil house. (Authors' collection.)

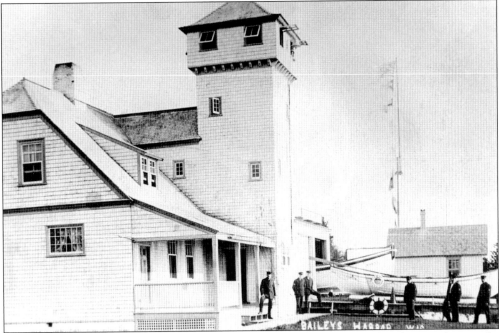

With its hundreds of miles of shoreline, Door County had a vital need early in its history for life-saving stations. The Baileys Harbor Station was the closest to Cana Island, about seven nautical miles distant. It was called upon repeatedly to come to the aid of vessels and mariners. Unless Lake Michigan was particularly violent, the crew from this base could be in Cana's vicinity in a relatively short time. (Courtesy Steven Karges.)

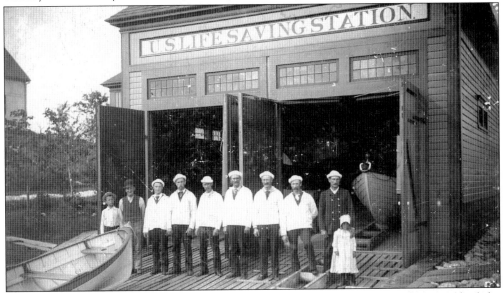

The first Door County Life-Saving Station was placed near the Lake Michigan end of the Sturgeon Bay Ship Canal in 1886. By water, Cana Island was 25 miles further north of Sturgeon Bay. Occasionally the life-saving crew had to journey 30 miles via the poor roads from the canal to Cana Island. When the schooner *Windsor* wrecked off Cana Island in 1893, it was over seven hours before help arrived by land. (Courtesy DCMM&LPS.)

# WRECK REPORT.

*Bailys & orton* Life-Saving Station, District No. 11

Date of Disaster:

*May 11*, 189 9

| | | | |
|---|---|---|---|
| 1. | Name of vessel. | 1. | *Thomas Davidson* |
| 2. | Rig and tonnage. | 2. | *Steamer 2.226 49.* |
| 3. | Hailing port and nationality. | 3. | *Milwaukee Wis U.S.* |
| 4. | Age. | 4. | *11 years.* |
| 5. | Official number. | 5. | *145482* |
| 6. | Name of master. | 6. | *W. B. Woods* |
| 7. | Names of owners. | 7. | *Mr Pauly* |
| 8. | Where from. | 8. | *Milwaukee Wis* |
| 9. | Where bound. | 9. | *Escanaba Mich —* |
| 10. | Number of crew, including captain. | 10. | *21.* |
| 11. | Number of passengers. | 11. | *None* |
| 12. | Nature of cargo. | 12. | *Light* |
| 13. | Estimated value of vessel. | 13. | *90.000* |
| 14. | Estimated value of cargo. | 14. | *No Cargo* |
| 15. | Exact spot where wrecked. | 15. | *Cana Island* |
| 16. | Direction and distance from station. | 16. | *7 miles E. N. E. from Star* |
| 17. | Supposed cause of wreck (specifying particularly). | 17. | *Foggy weather* |
| 18. | Nature of disaster, whether stranded, sunk, collision, etc. | 18. | *Stranded —* |
| 19. | Distance of vessel from shore at time of accident. | 19. | *100 yards.* |
| 20. | Time of day or night. | 20. | *4. P.m.* |
| 21. | State of wind and weather. | 21. | *Fresh S. Raing an Foggy* |
| 22. | State of tide and sea. | 22. | *moderate.* |
| 23. | Time of discovery of wreck. | 23. | *8 a. m* |
| 24. | By whom discovered. | 24. | *Keeper Recivis word* |
| 25. | Time of arrival of station-crew at wreck. | 25. | *9.38 a. m.* |
| 26. | Time of return of station-crew from wreck. | 26. | *6. P.m.* |
| 27. | Were any of the station-crew absent? If so, who? | 27. | *No —* |

Groundings and wrecks off Cana Island were fairly commonplace. The U.S. Life-Saving Service (later the Coast Guard) was responsible for rendering assistance to vessels in distress. The lighthouse keeper at Cana Island offered support on several occasions. This official wreck report documents the steamer *Thomas Davidson* having grounded in fog at Cana on May 11, 1899. Jesse Brown was keeper at the time. (Courtesy DCL.)

A raging storm in November 1958 sank the giant freighter *Carl D. Bradley* in northern Lake Michigan, three hours after the ship had turned northeast off Cana Island. Ferocious winds and waves 25 feet high sent 33 sailors to their death. Two lucky men survived. A coastal beacon, Cana was used by mariners as a location where course changes occurred and as a landmark to confirm their position. (Courtesy DCL.)

Automation began at many lighthouses beginning at the start of the 20th century. The Baileys Harbor Range Lights were converted to an automatic gas set up in 1922. Henry Gattie was the last keeper there and was transferred to Cana Island but also periodically checked back at the Range Lights. In 1930, a Lutheran church used the Upper Range Light as a parsonage. (Courtesy DCMM&LPS.)

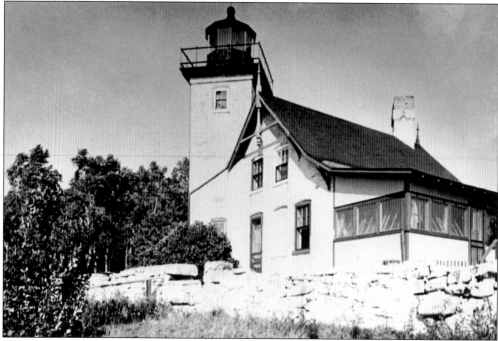

The Eagle Bluff Lighthouse is on the Green Bay side of the Door Peninsula near Fish Creek. The lighthouse was automated and became an unattended acetylene light in October 1926. The Cana Island keepers were then responsible for checking it regularly. The Cana keepers would first check on Eagle Bluff in April and would close it for the season in December. (Courtesy Steven Karges.)

These young men visited the lighthouse in 1938 prior to World War II. They photographed themselves in various places, here in the yard near a now departed barn, at the base of the lighthouse, and also at the tower's top. As is the case today, Cana attracted people and was a preferred Door County destination decades ago. (Authors' collection.)

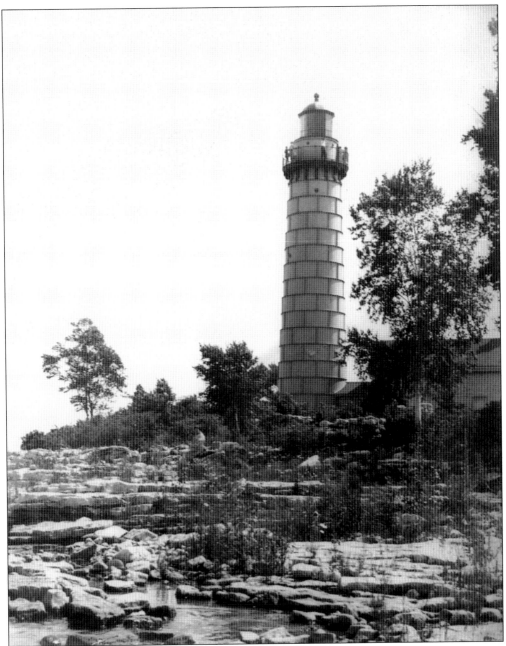

People have flocked to Cana Island for over a century. Keepers took thousands of visitors to the top for the grand view. This c. 1935 image shows a number of individuals positioned outside the watch room, overlooking Cana's jagged shoreline. Keepers also tallied the total annual number of tower climbers. In 1932, keeper Clifford Sanderson recorded taking nearly 2,000 people up and down the spiral staircase. (Courtesy DCMM&LPS.)

Tourists were not the only people who enjoyed the lighthouse. Local residents also visited "Caney Island," a term still used today. Many times families around Baileys Harbor knew the keeper and family well. Pictured here is Albert Zahn (bearded man standing with arms crossed with hat), a well-known Baileys Harbor neighbor. Zahn was a wood carver and artist. His unique "birdhouse" home still stands on the north end of Baileys Harbor. (Courtesy Randy Zahn.)

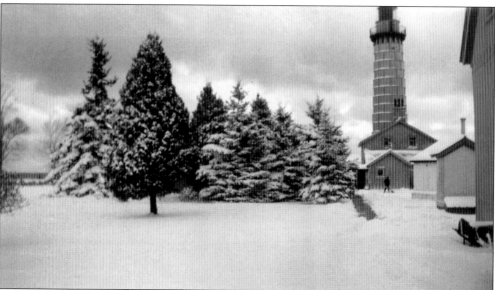

Historically Door County winters were to be reckoned with. Early Cana Island records mention the first snow as early as mid-October. The shipping season ended around late December and resumed again in mid-March. This c. 1930s picture paints a wonderful winter lighthouse scene. The person near the tower may have just shoveled the walkway. (Courtesy DCMM&LPS.)

In the station's inaugural years, Cana's light was extinguished when the lake froze and maritime traffic ceased. Even though Cana Island closed for the winter, some of the early keepers stayed at the lighthouse, others went to the mainland. In 1892, Jesse Brown was the first keeper to stay all winter. As larger more powerful steel ships were built in the early 20th century, the shipping season became yearlong. (Authors' collection.)

In 1924, the Cana Island Lighthouse began to burn acetylene gas in the lantern during the winter months. A pilot light and sundial controlled when the light was turned on or off. Keepers generally left the station during this time, but many of them visited monthly to check on the lighthouse. They normally wrote in the logbook simply "Found things all right." (Courtesy Louie and Rosie Janda.)

The winter landscape at Cana could be breathtaking. The station could be ice bound for several months. This is what the shoreline looked like during a typical winter. Slowly after the first few months of a new year, the ice began to break up out on open Lake Michigan. Later it would clear along the shoreline. By this time, the keeper had the lighthouse ready for the new shipping season. (Courtesy Louie and Rosie Janda.)

Before the advent of electricity, treadle sewing machines, this one seen around 1865, were the norm. The sewing machine was powered by the user's feet via a small platform near the base of the machine. Girls learned to sew at an early age, a skill that would prove quite useful for the women of the lighthouse. Each family had to be extremely self-sufficient. (Authors' collection.)

Looking down the stairway from the second floor of the keeper's quarters at Cana Island one can almost hear the laughter of the children sliding down the beautiful wooden banister. Almost all the woodwork in the house was painted, with the exception of this varnished banister. Sometimes the keepers chose the colors, other times it was determined by supply availability. (Authors' collection.)

The rock walls that still encircle parts of Cana Island are a tribute to earlier residents here. Beginning in April 1919, keeper Oscar Knudsen and various assistants began this monumental project. These sea walls prevented waves from taking a direct path into the yard during years of high water levels. It took three years to complete this stone barrier. (Authors' collection.)

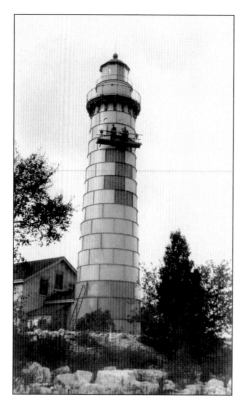

Painting was a never-ending job at Cana Island. The written logbooks refer to painting an endless number of times. Besides the rooms of the dwelling, the tower both inside and out were constantly attended to. Here a scaffold set up allowed the crew to paint some of the highest sections of the lighthouse. Today Cana's tower is white, but it has also been a light cream color in the past. (Courtesy DCMM&LPS.)

There are numerous mentions in Cana's logbooks of keeper's relatives, other family members, and friends coming to visit the island, especially during the warmer months. Many times, children spent some of their summer vacations there. This c. 1927 photograph features Edgar Bletcher, nephew of keeper Cliff Sanderson. The young man poses with a paint can and brush. Stained pants indicate he has been busy with painting chores, a constant activity on Cana Island. (Courtesy Edgar Bletcher family.)

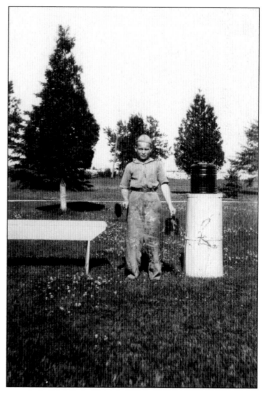

Cana Island children normally went to the nearby North Bay school, four miles away. Some children walked to school. Later with automobiles being more common, parents drove their kids. Here a group of young students pose for their picture (around 1935) outside North Bay school. Keeper Michael Drezdzon's daughter June is in the front row in a black coat. Her sister Virginia is in the middle wearing a beret. (Courtesy Virginia Smiddy.)

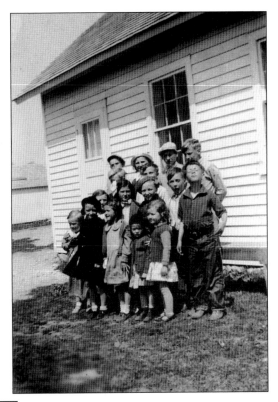

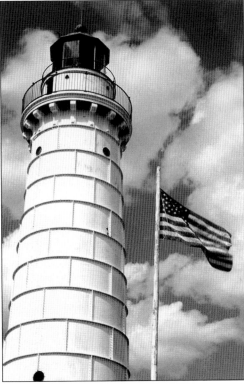

The United States flag flew over Cana Island for many decades. Its location varied over the years. Being an official government station, requirements would have the keeper raise the flag shortly after sunrise and remove it at dusk. A logbook entry from January 7, 1919, reads, "Flag at half mast to continue for 30 days in commemoration of death of President Roosevelt." (Authors' collection.)

The building attached to the rear of the lighthouse pictured here is called a summer kitchen. Cooking would have been done inside in the hot months to keep the main dwelling more comfortable. It also had accommodations for dining. A sundial on a pedestal rests outside near the kitchen. An inscription on it read, "My face tells of sunny hours, what can you say of yours?" (Courtesy Doris Rockwell.)

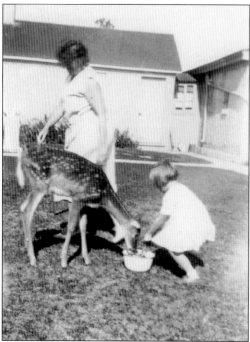

During the early 1930s, the Wright and Drezdzon families had a pet deer named Oscar. It was later determined that the deer needed to be renamed Oscarina! Here one of the Drezdzon children gives the deer some feed under the direction of Grace Wright. Virginia Drezdzon recalls making a pen for Oscarina; but the deer was startled by headlights one night and was injured and later died. (Courtesy Virginia Smiddy.)

During the time that Michael Drezdzon was stationed at Cana Island, he was paid $100 per month. His family often picked rhubarb and washed it at the water pump. Here June Drezdzon and her sister Virginia watch as their dad cuts up the plant. Susan Drezdzon would prepare the rhubarb in various ways in addition to canning it. Virginia recalls that to this day she dislikes rhubarb. (Courtesy Virginia Smiddy.)

Virginia Drezdzon has just about outgrown her tricycle as she peddles it in the yard at Cana Island, around 1937. The Drezdzon children would ride this bike all around the lighthouse yard as well as on the sidewalks. In the background of this photograph are a large barn, the oil storage house, and a cement pedestal that was topped with a sundial. (Courtesy Virginia Smiddy.)

June (left) and Virginia Drezdzon make good use of the concrete sidewalks at the Cana Island Station in 1938. They shared this Schwinn two-wheeled bicycle that came from the Montgomery Ward catalog. The girls also rode the bike over the causeway, which was dry during the 1930s, to go to the mailbox that was a few miles away. (Courtesy Virginia Smiddy.)

June (left) and Virginia Drezdzon spent much of their playtime with each other and their favorite dolls. Virginia remembers playing dolls often. They had a doll buggy that was wheeled along the sidewalks. Note the matching outfits on both girls and the sunbonnets. Virginia recalls her mother insisting the girls wear a sunbonnet much of the time. (Courtesy Virginia Smiddy.)

June (left) and Virginia Drezdzon are pictured here next to one of the concrete pillars that marked the walkway to Lake Michigan at Cana Island. Their playful kitten was called Tabby. They also had another cat named Bootsie. Notice the matching fabric on the girls' clothes. Nothing was wasted. June wears a short set and Virginia a dress. (Courtesy Virginia Smiddy.)

In 1940, Alice Mae Drezdzon was born at Eggland Hospital in Sturgeon Bay, Wisconsin. Here the three sisters, from left to right, Virginia, Alice Mae, and June, pose under a shade tree in front of one of the stone sea walls at Cana Island. The Drezdzon family did not remain at the lighthouse during the winter months but went to either Florida or Louisiana where the girls attended school. (Courtesy Virginia Smiddy.)

For young children, the summer months at Cana Island could be a carefree time. While there is no sandy beach, the girls could wade in the chilly water, splash in the waves or play in the yard. Left to right are Virginia Drezdzon, June Drezdzon, and Dorothy Jackson (great-granddaughter of keeper Jesse Brown), hamming it up for the camera. Paper chains adorn their heads. (Courtesy Virginia Smiddy.)

Virginia Drezdzon, age 12, models the new dress made by her mother at Cana Island in 1939. The Cana Island tower provides the background. Susan Drezdzon made all of the girls' clothing on a Singer treadle sewing machine that did not require electricity to power it. Virginia poses in front of one of the many flowerbeds on the island. Several of the keepers and families had green thumbs. (Courtesy Virginia Smiddy.)

Just before leaving Cana Island for the winter in 1936, Virginia (left) and June Drezdzon pose on the sled that they shared. The girls took turns pulling each other around the yard. Normally their parents were involved with the many day-to-day adult chores at the lighthouse that the youngsters occupied themselves with countless adolescent activities. (Courtesy Virginia Smiddy.)

A campground once existed across the bay west of Cana Island. Located along Cana Island Road, families came for decades to the Spikehorn campground. A beautiful Lake Michigan shoreline and a view of Cana Island (background) were a few of the amenities. Operated by the Augustine family until the late 1990s, the land is now part of the Baileys Harbor Boreal Forest and Wetland State Natural Area. (Courtesy DCMM&LPS.)

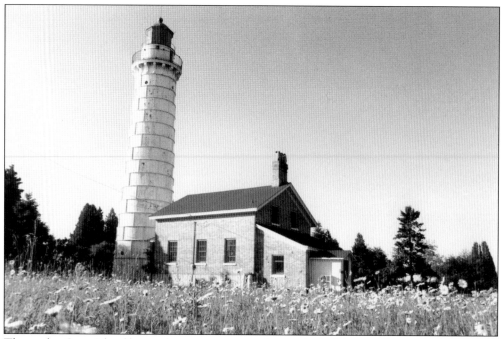

The yard at Cana Island has undergone numerous changes in its lifetime. Originally the area was just a clearing where trees and brush once stood. Later more room was made as further vegetation was removed. Evergreen trees, grass, daisies, other flowers, and trees would eventually all coexist. Early on, grass cutting was done with a push lawn mower. Yard maintenance continues to be job performed today. (Courtesy Louie and Rosie Janda.)

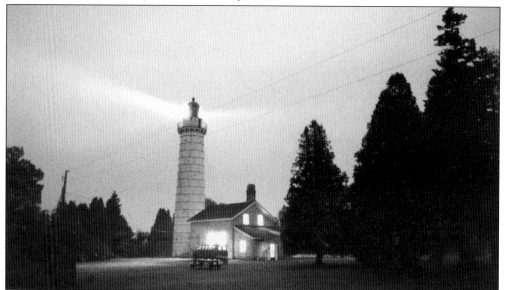

On a clear evening, Cana's light has a maximum range of 18 miles. Foggy weather would reduce the distance that mariners could see Cana's valuable beam. Cana Island never had a fog signal. The Plum and Pilot Island lighthouses in the dangerous Death's Door strait 15 miles northeast of Cana, however, did possess ear-numbing fog signals. Interestingly, under certain conditions, Pilot Island's foghorn could be heard at Cana. (Courtesy Louie and Rosie Janda.)

*Five*

# CURRENT STATUS
## PRESERVATION EFFORTS
## AND THE FUTURE

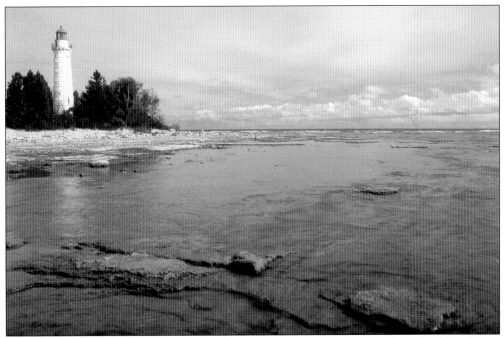

The Cana Island Lighthouse remains one of Door County's favorite sightseeing destinations. This striking sentinel is highly recommended if one visits Wisconsin's lighthouses. The Cana Island Light is one of a kind. Door County has no other beacon like it. A preferred subject for photographers and artists, an estimated 40,000 folks walk the causeway to visit this famous beacon each year. (Authors' collection.)

In the spring of 2006, the federal government transferred ownership of Cana Island to Door County. In partnership with the Door County Maritime Museum and Lighthouse Preservation Society, Cana Island is open seasonally from mid-May through October. The keeper's house, while not restored, is open when personnel are on duty and the grounds can be toured. A nominal admission fee is charged. The tower is not normally accessible because the light is still in service. People enjoy having their picture taken with the lighthouse in the background. (Authors' collection.)

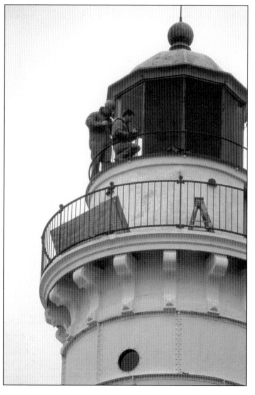

The Cana Island Lighthouse is still an active navigational beacon and is presently operated by the United States Coast Guard. Maintenance is performed by the Aids to Navigation Team from Green Bay, Wisconsin. Here a Coast Guard crew replaces one of the lantern room's glass panes. The weather and sometimes irresponsible people damage or vandalize the light. (Authors' collection.)

Much maintenance is still necessary at Cana Island. No longer are the keeper and family in residence to do the day-to-day work to insure the lighthouse looks ship shape. An endless list involves painting, plastering, roof work, yard upkeep, tower cleaning, and other projects. Cana's concrete base is crumbling in places and in need of repair. Dedicated people will be needed to see that Cana survives. (Authors' collection.)

The Cana Island Lighthouse is listed in the National Register of Historic Places. Visitors can get a glimpse of Door County unaffected by the hustle and bustle of much of the peninsula from spring through fall. The Coast Guard periodically visits the lighthouse for routine maintenance. Luckily vandalism has not been a recent major issue at Cana Island. (Authors' collection.)

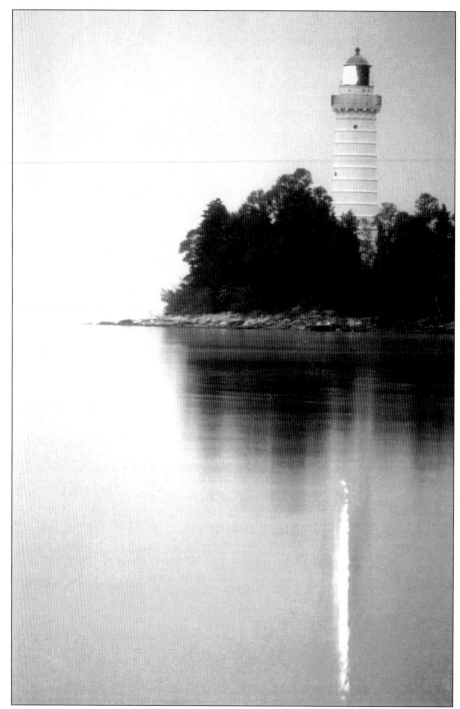

The future status of the Cana Island Lighthouse is changing. This light was one of several Door County lighthouses declared excess property by the federal government. With shifting priorities and dwindling resources, Uncle Sam wants to be out of the lighthouse business. Local and national governments, neighbors, and concerned citizens all ultimately determined a permanent solution for tomorrow's care of the Cana Island Lighthouse. (Authors' collection.)

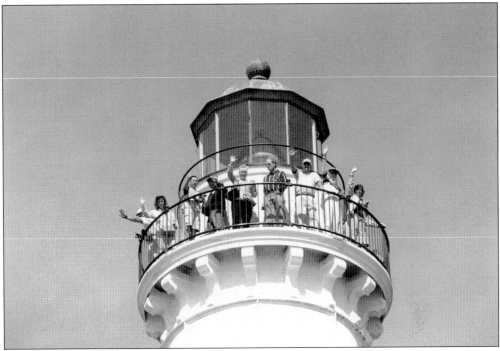

Annually the Door County Maritime Museum sponsors a Lighthouse Walk in mid-May. Presently nine of the lighthouses are open to the public, with historical information provided. Combinations of walking tours, boat trips, and special sightseeing opportunities make for an exciting weekend for the lighthouse buff. (Courtesy Jon Jarosh, Door County Chamber/VCB.)

To reach Cana Island, go north out of Baileys Harbor on Highway 57. Turn right at County Q. Continue past Moonlight Bay. Watch for the Cana Island sign at approximately three and a half miles and turn right. Proceed to the stop sign at Cana Island Road and turn right. Follow the signs for one mile, take a left turn following more lighthouse signs. The road ends near the causeway. (Authors' Collection.)

Traveling along Cana Island Road, one will notice private property and speed limit signs. The road narrows and becomes wooded and residential as one approaches the rocky causeway. Some of Cana's neighbors have concerns regarding their privacy and land. Parking space is limited. Please be courteous to local landowners and respect their property lines and seclusion. (Authors' collection.)

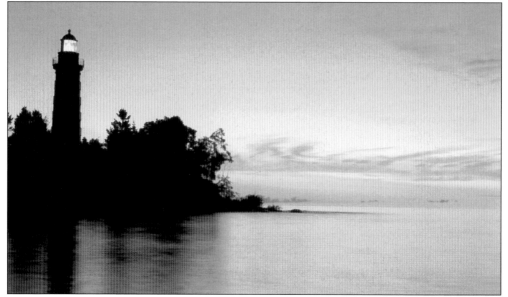

Cana Island's history is filled with everyday life, dedication, and bravery. It continues to be alive with the spirit of its keepers. Each night the Cana Island light still shines on, having guided mariners in three different centuries. It is hoped that this magnificent beacon's future is as bright as its long and storied past. All should strive to keep this legend alive and the light burning. (Authors' collection.)

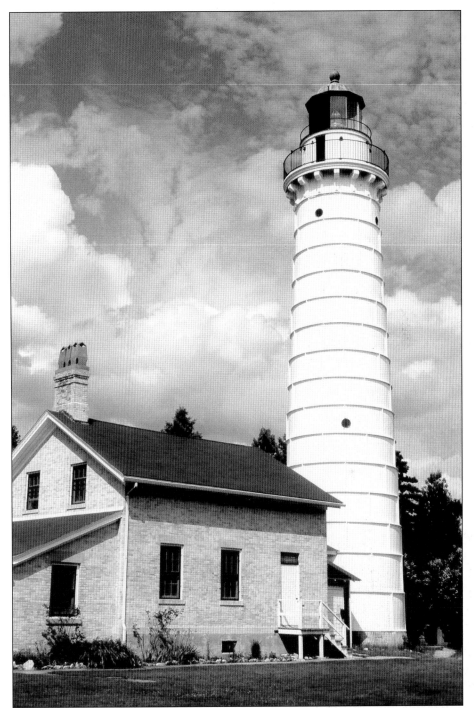

Visitors to the Cana Island Lighthouse should place themselves at this viewing point. It is one of the most favored locations for those with a camera. Imagine all the history here: loyal keepers, pounding storms, endless work, cool summer winds, children frolicking in the yard. Think about becoming involved in preserving this Door County legend for future generations. The Cana Island Lighthouse deserves no less. (Authors' collection.)

# SELECT BIBLIOGRAPHY

Ellison Bay Centennial History Committee. *A Century in God's Country, 1866–1966*. Ellison Bay, WI: 1966.

Erickson, James Arnold. *North Bay: Door County, Wisconsin*. Freeman, SD: Pine Hill Press, Inc., 1998.

Frederickson, Arthur and Lucy. *Ships and Shipwrecks in Door County, Wisconsin: Volumes 1 and 2*. Sturgeon Bay, WI: Door County Publishing Company, 1961, 1963.

Holand, H.R. *Old Peninsula Days*. Minocqua, WI: NorthWord Press, 1990.

http://dcmm.org/

http://www.archives.gov

http://www.gllka.com/

http://www.terrypepper.com/lights/index.htm

http://www.uscg.mil/hq/g-cp/history/collect.html

http://www.wisconsinmaritime.org/

Karges, Steven. *Keepers of the Lights: Lighthouse Keepers & Their Families: Door County, Wisconsin, 1837–1939*. Ellison Bay, WI: Wm. Caxton Ltd., 2000.

Thomas, Stacy and Virginia. *Guarding Door County: Lighthouses and Life-Saving Stations*. Charleston, SC: Arcadia Publishing, 2005.

Wardius, Ken and Barb. *Wisconsin Lighthouses: A Photographic and Historical Guide*. Madison, WI: Prairie Oak Press, 2000.